BURIED TREASURES

THE BLACK-AND-WHITE WORK OF
MAXFIELD PARRISH • 1896 – 1905

BURIED TREASURES

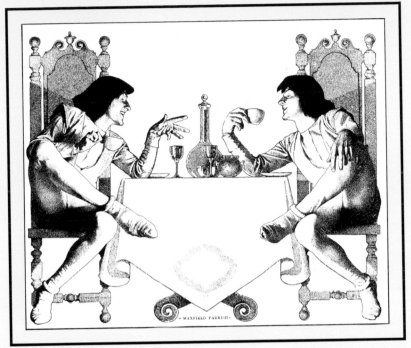

THE BLACK-AND-WHITE WORK OF
MAXFIELD PARRISH • 1896 – 1905

EDITED BY FERSHID BHARUCHA

TEXT BY ROSALIE GOMES

POMEGRANATE ARTBOOKS • SAN FRANCISCO

In memory of Phil Seuling

Without whom: Norman Witty, Peter Maresca, Bud Plant, Lillian Grossman, Terence Brown and Tom and Katie Burke. And special thanks to John Goodspeed Stuart of the Parrish House, 1740 Marion Street, Denver, Colorado 80218, for all his time and help in finding the most elusive items in this book.

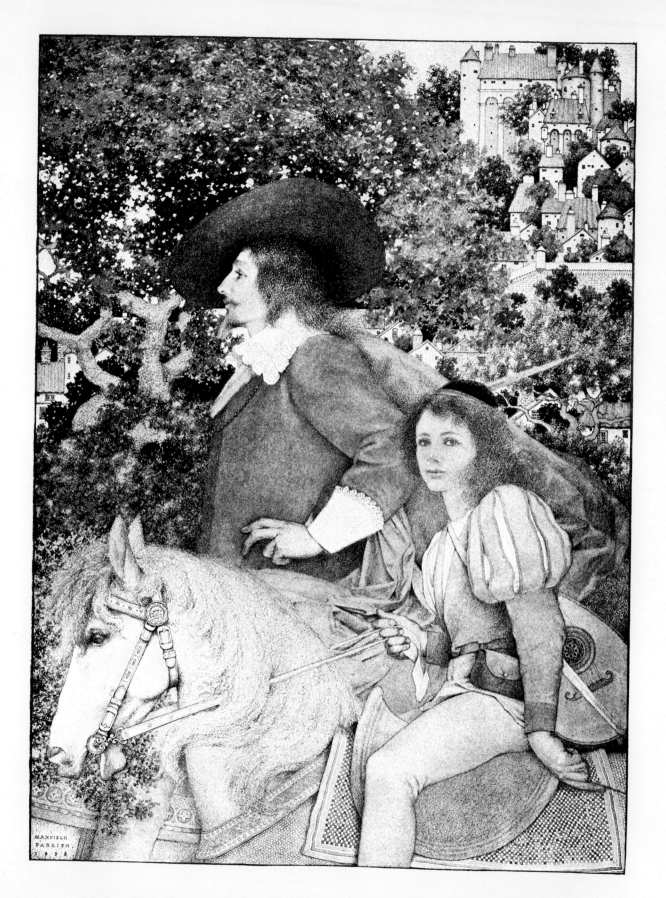

A Journey through Sunny Provence in the Days of King René, 1898
PUBLISHED AS AN ILLUSTRATION FOR A MASTER OF MAKE-BELIEVE
BY CHRISTIAN BRINTON, CENTURY MAGAZINE, JULY 1912

"The dawn is more radiant [in Maxfield Parrish's paintings] than Aurora dare tint her, and the sunsets have a prismatic splendor visible only to painter and poet."

Christian Brinton, 1912

Maxfield Parrish has become so closely identified with the brilliant blue skies and mauve mountains of his paintings that his bold but subtle black-and-white illustrations have been largely ignored. Yet almost all his early work, which first brought him recognition, was in black and white. It already showed the qualities of design and draftsmanship that would win him wider acclaim in later years: strong composition, boldness of outline and elaborate rendering. The excessive romanticism of some of the calendar paintings had not yet entered his work, and the tendency toward sentimentality was, as always, balanced by humor.

A Brief Biography

Parrish was born on July 25, 1870. Christened Frederick Parrish, he later adopted Maxfield, his paternal grandmother's maiden name, as a middle name before finally dropping "Frederick" altogether from his professional name.

Stephen Parrish, Maxfield's father, was an artist. Having grown up in a strict Quaker household in which art was frowned upon, he had had to struggle to become a professional etcher. But he encouraged his son's interest in art from childhood. When Frederick was only three years old, Stephen gave him his first sketchbook, which he gradually filled up for the boy with humorous drawings of animals. When he was older, Stephen taught him to paint and draw. Parrish always claimed that his father had been his greatest artistic influence, and he was always very close to him.

In 1884, when he was fourteen, Parrish went to Europe with his parents. The family spent two years traveling in England, Italy and France. Throughout the trip young Parrish wrote regularly to his grandmother and a cousin. Those letters, filled with sketches and amusing anecdotes, are a marvelous record of the young boy's impressions and his keen sense of observation. In his written descriptions he shows a great interest in architecture, which figures prominently in his later work. His

parents took him to museums, concerts and the opera, all of which he greatly enjoyed.

In 1886 the Parrishes returned home, and two years later Maxfield, who at this time was planning a career in architecture, entered the famous Quaker Academy, Haverford College. Although art was not a part of Parrish's curriculum, he amused himself by painting elaborate murals on the wall of the room he shared with Christian Brinton. Brinton later reminisced about their time together at Haverford:

"The suite in Barclay Hall quickly became the wonder of upper as well as lower classmen. He was willing to take incredible pains to achieve a desired effect. If the wall surfaces, for instance, were found lacking in tone or design, he would borrow a step-ladder from the mistrustful janitor, and pass joyous afternoons dashing in with crayon or colored chalk the most diverting wreaths and garlands. . . . Antique stores were ransacked for appropriate bits of furniture, brass or pewter."

By 1892, when he enrolled at the Pennsylvania Academy of Fine Arts, Parrish knew he wanted to be a painter and illustrator. At this time he also sat in on some of Howard Pyle's classes at the Drexel Institute. But for all practical purposes his student days were over. While still studying, Parrish was already working professionally and getting important commissions.

Parrish's first major work was the Old King Cole mural for the Mask and Wig Club at the University of Pennsylvania in Philadelphia in 1894. The King Cole motif was to recur again and again throughout his career; the most famous example is the mural he painted for the Hotel Knickerbocker, now moved to the Sheraton St. Regis Hotel in New York.

When he finished his studies, Parrish rented a studio in Philadelphia and began doing book and magazine illustrations and designing advertisements for various local companies.

In 1895 he married Lydia Austin, an art

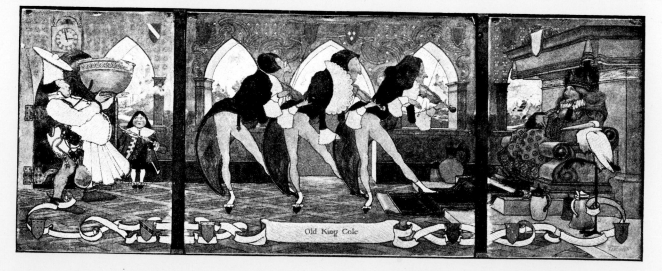

Old King Cole, from a sketch for a decoration in the Mask and Wig Club, University of Pennsylvania, Philadelphia

teacher he had met at the Drexel Institute. Shortly thereafter, leaving his young bride behind, Parrish sailed for Europe. His enthusiasm for the museums was as great as in his boyhood, but he saw nothing he liked in the salons where the works of modern European artists were displayed. His frequent letters to his wife recorded his artistic interests and tastes at the time.

"Oh, the masters of the Dutch and Flemish schools knew how to paint!" he wrote from Brussels. And in Paris he "nearly fainted" when he walked into the Louvre and saw all the "Titians, Rembrandts, Botticellis, Correggios, Van Eycks, all together in one glorious mosaic of richness." However, he had nothing but contempt for the contemporary art at the Salon, especially the "colossal representation of a newly cut-open ox, dripping, swimming, wallowing in crimson, animal blood!" Nothing could be further from Parrish's own subjects, from which all bloodshed and conflict have been banished in favor of idealized characters, storybook magic and fairy-tale charm. He left Europe convinced that "America will one day have modern exhibitions to show that will outclass any on this side of the water."

Parrish spent another three years working in Philadelphia before moving permanently to "The Oaks," the house he designed and built himself (with the help of only one carpenter) in Cornish, New Hampshire. The house was photographed and featured in many architectural magazines of the day, and Parrish, who had had no formal training as an architect, was widely praised for his skill and sense of form.

The years around the turn of the century were difficult ones for Parrish. In 1898 his mother left his father, and the resulting scandal must have been doubly painful for Maxfield, who was both very close to his father and a very private, even secretive, person.

In 1900, only two years after moving to The Oaks, Parrish almost lost the house because of financial difficulties. That same year, he was found to have contracted tuberculosis, and his doctor advised him to spend the winter at Saranac Lake, New York.

The pressures he had to endure during these years may have resulted in a nervous breakdown. But little is known with any certainty, and nothing in Parrish's work from that time indicates any anguish or torment. Throughout his life, his work continued to radiate serenity and well-being.

Parrish's tuberculosis had an unexpected artistic consequence. In spite of his illness, he continued to paint at Saranac Lake. He was getting more and more commissions, and, with his financial difficulties, he did not feel he could afford to interrupt his work. Before Saranac, most of his work had been in black and white. But when his inks froze in the cold weather, he was forced to try another medium. He switched to oils, developing the brilliant colors that became his hallmark.

After his first treatment for tuberculosis, Parrish was not fully recovered, so his doctor ordered him to spend the next two winters in Arizona. Once again he combined work and convalescence. The editor of *Century Magazine* had asked Parrish to illustrate a series of articles about Arizona, and Parrish was kept busy rendering the canyons and mountains around Hot Springs, Arizona.

The second winter in Arizona was followed by another trip to Europe to illustrate Edith Wharton's *Italian Villas and Their Gardens* (The Century Company, November 1904), his first book with color illustrations. After his long absences from The Oaks, Parrish was glad to return home in the spring of 1903.

Parrish had moved to the country because he needed the isolation to work, but he also enjoyed the busy social life of the summer months, when Cornish was transformed into a fashionable artistic and literary colony. Guests at The Oaks included actress Ethel Barrymore, Scribner editor Maxwell Perkins and well-known newspaperman Walter Lippmann. Every year, for their own amusement, the Cornish summer residents would put on theatrical productions, for which Parrish invariably designed the sets and costumes. He enjoyed building the sets, with the help of his carpenter, in The Oaks' well-equipped machine shop. Many of the giant vases and other props used in his paintings were also built in the shop.

After the busy summers, the winters must have seemed bleak, but Parrish took advantage of the calm to catch up on his steady stream of commissions.

Sometime between 1905 and 1911 the Parrishes' marriage began to break down. Although they always denied the problems in their marriage and kept up a pretense of conjugal life during the summers, by 1911 Parrish had moved out of the main house to the studio at The Oaks while Lydia wintered at her house in Georgia.

Whether it was cause or effect of the Parrishes' marital woes, Maxfield was not alone in the studio. His companion there for nearly fifty-five years was Susan Lewin, a woman originally hired as a sixteen-year-old girl in 1905 to help care for Dillwyn, the Parrishes' first child. Within a short time Lewin was modeling for Parrish, who photographed her in a variety of poses and costumes, which she also cut and stitched. Her likeness appears in many of Parrish's paintings.

The studio was quite large, especially conceived to accommodate the huge murals Parrish executed for hotels and private homes. Here, Maxfield Parrish and Sue Lewin lived in nearly complete isolation through the bitter winters. Often when the roads were blocked with heavy snows, The Oaks was completely cut off and Parrish had to run his errands on snowshoes.

The Oaks played a major role in Parrish's life: it was his base and the place in which the

vast majority of his work was done. Except for a few short absences, Parrish was to spend the rest of his life in Cornish, drawing, painting or working in his machine shop for relaxation. He was able to paint until the age of ninety-one, when arthritis and poor health forced him to stop. He died at The Oaks on March 30, 1966, at age ninety-five.

In 1912 Parrish's friend Christian Brinton described what he regarded as the essence of Parrish's work. Today his words are still an accurate summary of the artist's career:

"There is still in all this work a flexibility of spirit which bespeaks the typically free, unfettered temperament. ...He finds himself, and he has the gift of making you feel, equally at home any-

where—that is, anywhere in the land of Make-Believe; for the restless, stressful existence about him offers little interest or stimulus. Above all, he preserves in each transition the precious spontaneity of youth. This art is manifestly adolescent expression. The element of amusing or alluring distortion is seldom absent. The dragons are more avowedly voracious, the genii more malevolent, and the questing little adventurers more valiant than any met elsewhere....

"This art at no point touches life as we, alas, are forced to accept it. It seeks no compromise with fact, for it exists quite independently of what we are pleased to term truth to nature. Technically as well as in subject-matter it stands apart from current production. In so far as it is not strictly individual, its method is based upon the practice of certain masters who lived long since and who have perpetuated the tradition of fresh, bright color and clean, well-defined contour. You seldom see in these canvases broken surfaces or any attempt to create the so-called illusion of reality. There is little movement, even. The figures are static, and each separate scheme is planned with a regard for proportion and balance which admits of nothing impromptu....The calm of the dream world has spread itself over these carefully wrought compositions. And in studying them you are unwilling to decide whether he cannot, or merely does not care to, confront broader issues and face more complicated problems.

"It is in no small degree its persistent juvenility that is responsible for the continued popularity of his work. It represents a protest—

The Militiaman, a paper cutout. Published as an illustration for "A Master of Make-Believe" by Christian Brinton in *Century Magazine*, July 1912

an unconscious one, if you will—against the precocity of the coming generation. With clarity of vision and vigor of representation it keeps alive sentiments which are in danger of suffering extinction."

Parrish's Illustrations

Today Parrish is primarily remembered for his paintings and their brilliant colors (especially the famous "Parrish blue," which is simply pure cobalt, straight from the tube), yet some of his best works are to be found among the black-and-white illustrations he produced early in his career.

At that time, before he devoted himself almost exclusively to painting, Parrish's illustrations appeared frequently in *Century Magazine*, *Life*, the five *Harper's* magazines, *Collier's*, *Scribner's*, *Ladies' Home Journal* and other contemporary magazines. The beginning of Parrish's career coincided with the tail end of the golden age of illustrated magazines. By the middle of his career, photography had almost entirely replaced illustration.

Even as a young beginning artist, Parrish enjoyed experimenting with a variety of techniques, from the simplest to the most complex. For many of his early magazine covers, as well as for his first two books,

Mother Goose in Prose, by L. Frank Baum, and *Knickerbocker's History of New York,* by Washington Irving, he favored a simple stipple technique (applying tiny dots to produce gradations of shade), but he used it to achieve near-photographic realism, which is very difficult to do with this process. Other examples of stippling are the double-page spread illustrating the poem "Christmas Eve," published in *Century Magazine* in December 1898, Parrish's illustrations for "A Hill Prayer," published in *Century* in December 1899, and the title page of this book, originally executed for *Life's* 1899 Christmas issue.

In other illustrations dating from this period, Parrish experimented extensively, mixing techniques, processes and materials to see what effects he could obtain. In certain cases, he started out with a wash drawing on Steinbach paper and finished rendering it with lithographic crayon, pencil, ink and crayon. Parrish's illustrations for Edith Wharton's "The Duchess at Prayer" (*Scribner's Magazine*, August 1900), for example, were elaborately rendered and the product of great technical experimentation.

Some drawings were executed on watercolor paper with crayon and ink and later varnished and finished in oil. In some instances, fortunately not very many, Parrish would provide a drawing

for black-and-white reproduction, and at the last minute the publisher would decide to add color tints dropped in by the engraver. Examples of this editorial disrespect are the illustrations for "The Rape of the Rhine-Gold" (*Scribner's Magazine*, December 1898). For purposes of authenticity, in this book the color tints have been photomechanically dropped out again for these illustrations.

Parrish's color experimentation was even more complex. In some cases, there were no originals: he worked directly on the lithographic stone, doing up to nine color separations on different stones for each illustration. This meant he did the same drawing nine times, rendering each color separately. Once the illustration was printed, the stone was wiped clean and the "original" disappeared forever.

In response to an inquiry about his color technique, Parrish explained: "This method of painting is by no means original with me: in fact it goes back to as far as the 13th–14th century and the Van Eyck brothers. Simply stated, it is nothing but painting with transparent oil colors over a white ground...."

Left and above: Design and illustration for "Wagner's Ring of the Nibelung,
Part I: The Rape of the Rhine-Gold," by F. J. Stimson, *Scribner's Magazine*, December 1898

"The advantage of transparent (or glaze) over the usual method of mixing tints on a palette is beyond belief: you have a new set of colors: colors you look 'into' instead of 'on.' A transparent cobalt glazed over a white ground is quite different from a cobalt mixed with white of exactly the same value. It is all a question of 'quality.' Colors are never mixed [but] used just as they come from the tube in their original purity. As an example, in painting a green tree: with long observation you get to know there is a lot of red in such, and in mixing red with green you get mud. The other way, when your green tree is dry you glaze over it, say, rose madder, taking off as much as you see fit. That is the whole idea. It may take years to make such a method your own, but it's worth it. And to tell of all the ins and outs would fill a volume and soon be forgotten. To put on one's shoes and stockings for the first time from printed directions would be quite a job...."

Parrish was an excellent craftsman who enjoyed the technical aspect of his art. But above all he was an imaginative illustrator endowed with a keen sense of humor. The first book Parrish illustrated gave him an opportunity to exercise his whimsical humor. It was L. Frank Baum's *Mother Goose in Prose*, first published by Way and Williams of Chicago in 1897. The book had fourteen black-and-white illustrations as well as a color cover by Parrish. Its success brought both artist and writer to public attention. Baum later became famous as the author of the Oz books.

Parrish clearly had fun illustrating Baum's book. He dressed his characters in elaborate medieval-looking costumes and often filled the backgrounds with carefully rendered castles, turrets and fortifications (as in the illustrations for "Humpty Dumpty" and "Little Boy Blue"). No castle outside a Parrish book or a Disney theme park ever looked like these!

Even Parrish's most humorous or grotesque characters are endowed with a certain elegance and grace. His Humpty Dumpty sits so daintily on his wall that you would never guess he was about to fall off. As befits an egglike creature, he is fat and oval, but his arms and legs are slim and positioned as gracefully as a ballet dancer's. The same is true of the confused-looking Man in the Moon, who seems to be vacillating between staying on his precarious perch and stepping down into the peaceful countryside. Knowing Parrish's love for landscape painting (in his later years he refused to paint people and devoted himself entirely to landscape art, which he regarded as his "serious" work), it is important to pay careful attention to the idealized natural scenery that serves as a backdrop for so many of his early illustrations. His love of nature is as apparent as is his interest in architecture.

In the most successful illustrations for *Mother Goose* there is an exaggeration of salient details that is close to caricature. The

Three Wise Men of Gotham, who sit wrapped up in sheets in the bowl that is taking them to sea, seem to float on the page. There are no other details to distract us from their faces, which testify to Parrish's talent for comedy and a rather benign form of the grotesque.

Not all of the *Mother Goose* illustrations are humorous. The subtle toning of "Little Bo-Peep" and the dreamy atmosphere of "Little Boy Blue" are in the more realistically rendered, and at the same time more romantic, style that Parrish was to make famous with his paintings of nymphs on rocks and pre-pubescent children.

After completing *Mother Goose*, Parrish was asked to illustrate *Knickerbocker's History of New York*, written by Washington Irving in 1809. It took Parrish eighteen months to finish the book's nine illustrations, which he squeezed in between other commissions. The book was published by R. H. Russell of New York in 1900. Irving's satirical style provided Parrish with another occasion for comic illustration, though Parrish's own brand of humor is less harsh than the author's. Where Irving is unrelievedly severe in his judgments, the artist seems more intent on producing an attractive image. Parrish always felt free to depart from the text when it suited his artistic whims and desires, often using his various styles in unexpected ways. For the famous witch in the *Knickerbocker* book, for example, he chose a photographically realistic rendering to depict a fantasy image. The surprise element adds to the vividness and believability of the witch.

Perhaps the most striking illustration in the book is that of the Indian with a giant jug of liquor hovering in the background in total disregard for all laws of perspective and proportion. It clearly demonstrates Irving's condemnation of the white man:

"But no sooner did the benevolent inhabitants of Europe behold their [the Indians'] sad condition than they immediately went to work to ameliorate and improve it. They introduced among them rum, gin, brandy, and the comforts of life; and it is astonishing to read how soon the poor savages learned to estimate these blessings. . . . By these and a variety of other methods was the condition of these poor savages wonderfully improved: they acquired a thousand wants of which they had before been ignorant; and as he has most sources of happiness who has most wants to be gratified, they were doubtlessly rendered a much happier race of beings."

Parrish's illustrations of Dutch burghers in broad-brimmed hats were followed by a series of drawings for two children's books by English writer Kenneth Grahame. Parrish liked the greater freedom he found in working for a younger audience, and the collaboration between author and artist was a happy one. The first of the two books was *The Golden Age*, for which Parrish did nineteen full-page illustrations and many small vignettes. He

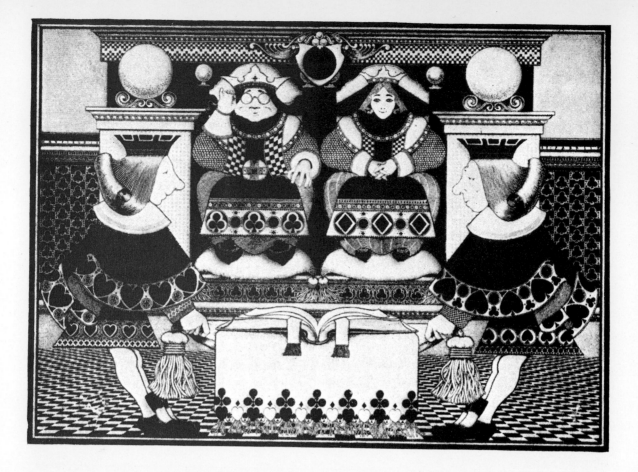

executed them between March and August of 1899 while he was working on the *Knickerbocker* book. The edition illustrated by Parrish was published in 1899 simultaneously in New York and London by John Lane of the Bodley Head, and it made Parrish as popular with British readers as he already was with the American public.

The Golden Age and its sequel, *Dream Days*, tell the adventures of a family of four English children. The stories are written entirely from the children's point of view. The adults are referred to as Olympians and described as "stiff and colorless...without vital interests and intelligent pursuits." The children resent the Olympians' authority and rebel against it much

as a colonized nation against an imperial power. Parrish successfully recreated the mood of Grahame's stories. In one of them, "The Roman Road," for example, the child narrator meets an artist who tells him he lives in Rome. In Parrish's illustration we are behind the child's back as we look up at the artist (who is obviously much taller than we are) and the magical city that rises up behind him. We are as full of awe and amazement as the small boy for whom Rome is a place of storybook fantasy. In another illustration a huge, frightening figure of a man looms over a hedge, and again we are watching from the child's point of view.

"It was easy—if your imagination were in healthy working order—to transport yourself in

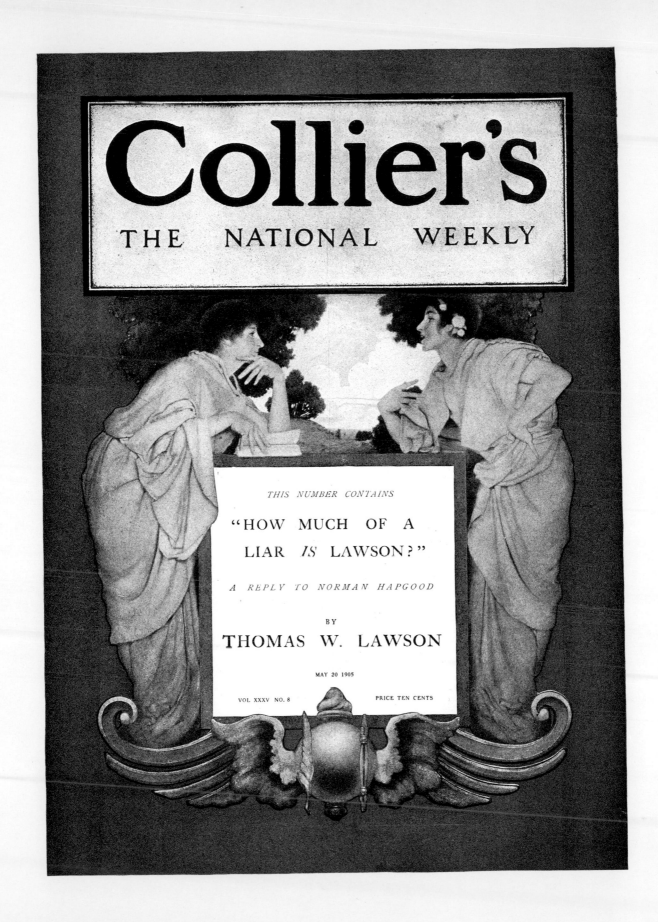

Collier's

THE NATIONAL WEEKLY

THIS NUMBER CONTAINS

"HOW MUCH OF A
LIAR *IS* LAWSON?"

A REPLY TO NORMAN HAPGOOD

BY

THOMAS W. LAWSON

MAY 20 1905

VOL XXXV NO. 8 PRICE TEN CENTS

Cover illustration for *Collier's, The National Weekly*, May 20, 1905

a trice to the heart of a tropical forest," says the child narrator of *The Golden Age*. Parrish's very healthy imagination captures the magic of childhood, especially in the illustrations depicting the children at play: pretending to be Jason in search of the Golden Fleece or imagining an encounter with a reluctant dragon. But in spite of Parrish's uncanny ability to recreate a child's perspective, his view of childhood is ultimately that of an adult nostalgic for a golden age that never was.

John Lane had commissioned Parrish to do the ten illustrations for *Dream Days* in color. The smaller vignettes were in black and white. But when the book came to be printed in 1902, Lane decided to do the whole book in black and white, using a new engraving process that eliminated the "dot-screen" pattern from the printed illustrations. Pleased with the results, which were superior to those obtained with the half-tone process used for *The Golden Age*, Lane decided to produce a new edition of the first book. Thus in 1904 *The Golden Age* was reissued as a companion volume to *Dream Days*, with matching bindings for the two books designed by Parrish.

Parrish illustrated several other books, including the well-known *The Arabian Nights*, but these four (*Mother Goose in Prose, Knickerbocker's History of New York, The Golden Age* and *Dream Days*) were his only black-and-white books. The public's unflagging demand for Parrish's brilliant color prints, calendars, illustrations and magazine covers resulted in the overshadowing of the more subtle black-and-white illustrations.

The purpose of this book is to draw attention to those early works. Most of Parrish's major book and magazine illustrations in black and white are reproduced here. Every effort has been made to be as faithful as possible to the originals and to obtain the best quality of reproduction so as to do justice to the sophistication of Parrish's technique.

"Try as you may, you cannot locate any of these quaintly capricious beings or the backgrounds, natural or architectural, against which they are amassed. All you know is that they belong to a place where one is ever young, and that they spontaneously awaken in you memories of having once been there yourself."

Christian Brinton, 1912

All quotations by Christian Brinton are from "A Master of Make-Believe," by Christian Brinton, *Century Magazine*, July 1912.

MISCELLANEOUS ILLUSTRATIONS FOR

POSTERS, MAGAZINES AND PROGRAM COVERS

AND MAGAZINE ARTICLES AND STORIES.

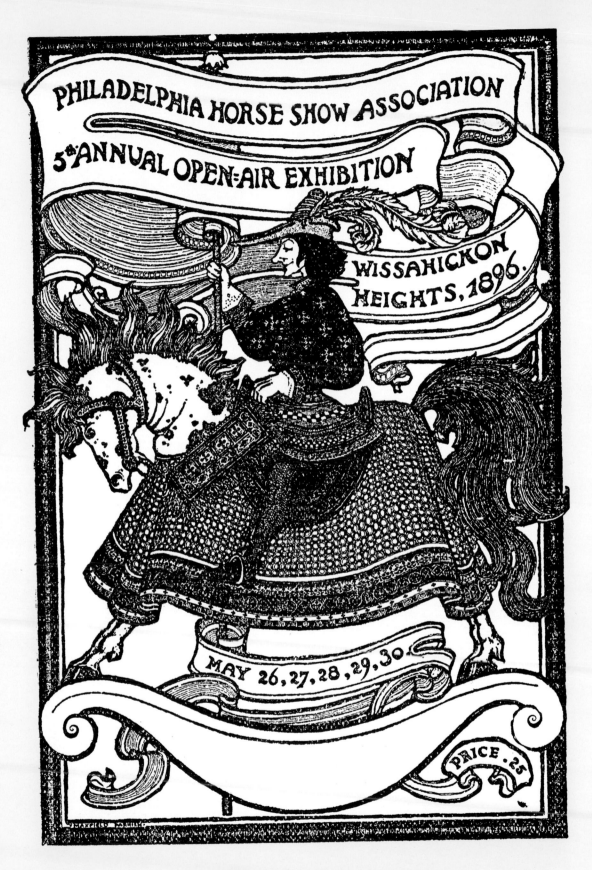

Philadelphia Horse Show Association
Poster for 5th Annual Open-air Exhibition, 1896
PUBLISHED AS AN ILLUSTRATION FOR THE ARTICLE MAXFIELD PARRISH
IN BRADLEY: *HIS BOOK*, NOVEMBER 1896

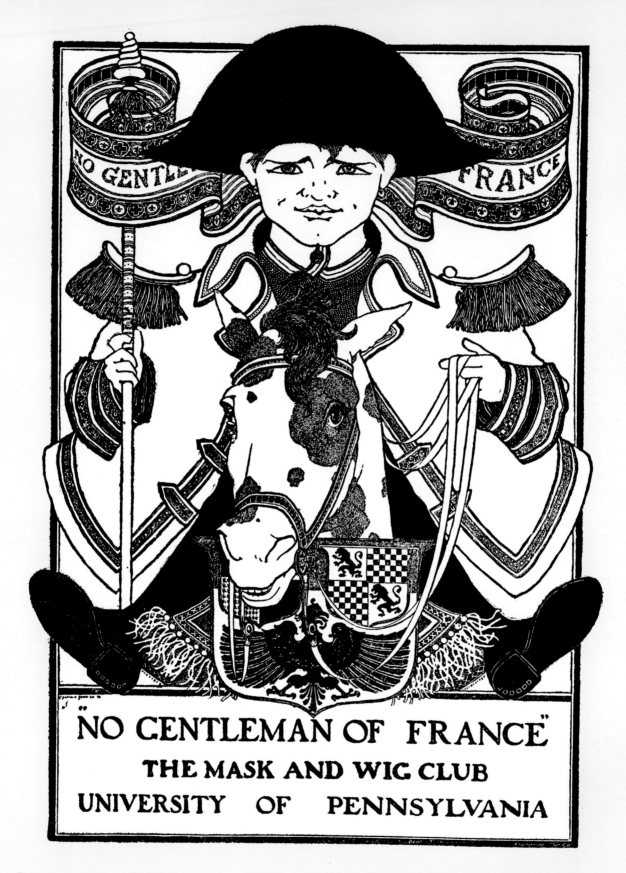

"NO GENTLEMAN OF FRANCE"
THE MASK AND WIG CLUB
UNIVERSITY OF PENNSYLVANIA

Program Cover for The Mask and Wig Club production of No Gentleman of France,
University of Pennsylvania, c. 1896
PUBLISHED AS AN ILLUSTRATION FOR THE ARTICLE MAXFIELD PARRISH
IN *BRADLEY: HIS BOOK*, NOVEMBER 1896

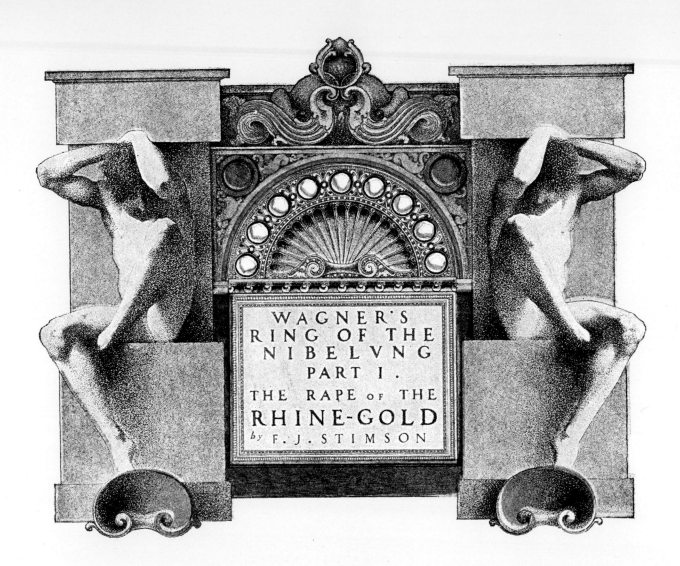

WAGNER'S
RING OF THE
NIBELVNG
PART I.
THE RAPE OF THE
RHINE-GOLD
by F. J. STIMSON

TITLE ILLUSTRATION AND PAGE ILLUSTRATIONS (FOLLOWING PAGES)
FOR "WAGNER'S RING OF THE NIBELUNG, PART I: THE RAPE OF THE RHINE-GOLD"
BY F. J. STIMSON, *SCRIBNER'S MAGAZINE*, DECEMBER 1898

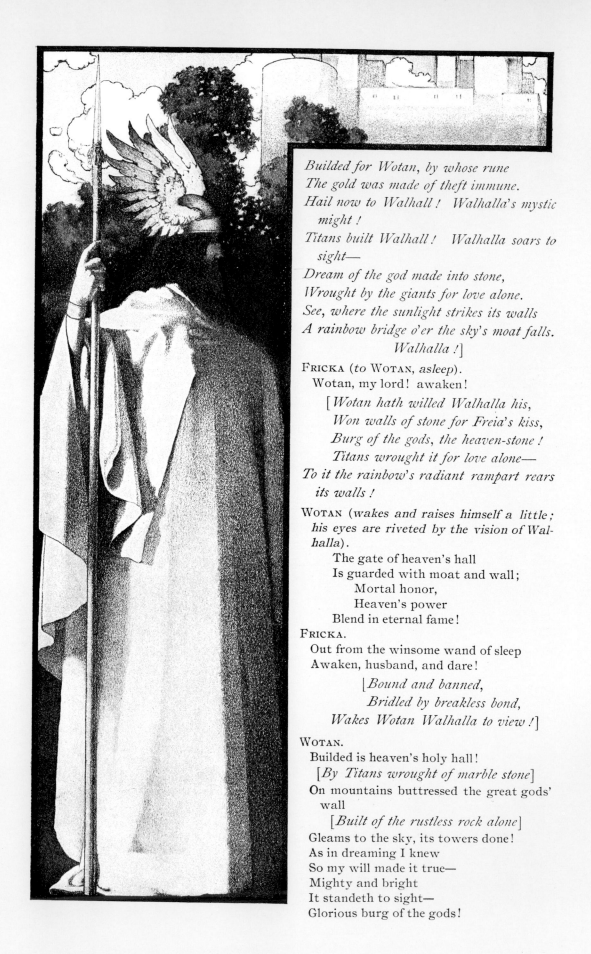

Builded for Wotan, by whose rune
The gold was made of theft immune.
Hail now to Walhall! Walhalla's mystic
* might!*
Titans built Walhall! Walhalla soars to
* sight—*
Dream of the god made into stone,
Wrought by the giants for love alone.
See, where the sunlight strikes its walls
A rainbow bridge o'er the sky's moat falls.
* Walhalla!]*

FRICKA (*to* WOTAN, *asleep*).
 Wotan, my lord! awaken!

 [*Wotan hath willed Walhalla his,*
 Won walls of stone for Freia's kiss,
 Burg of the gods, the heaven-stone!
 Titans wrought it for love alone—
To it the rainbow's radiant rampart rears
 its walls!

WOTAN (*wakes and raises himself a little;*
 his eyes are riveted by the vision of Wal-
 halla).
 The gate of heaven's hall
 Is guarded with moat and wall;
 Mortal honor,
 Heaven's power
 Blend in eternal fame!

FRICKA.
 Out from the winsome wand of sleep
 Awaken, husband, and dare!

 [*Bound and banned,*
 Bridled by breakless bond,
 Wakes Wotan Walhalla to view!]

WOTAN.
 Builded is heaven's holy hall!
 [*By Titans wrought of marble stone*]
 On mountains buttressed the great gods'
 wall
 [*Built of the rustless rock alone*]
 Gleams to the sky, its towers done!
 As in dreaming I knew
 So my will made it true—
 Mighty and bright
 It standeth to sight—
 Glorious burg of the gods!

FRICKA.

But a joy 'tis to thee—
To me, a fear—
The burg's thy delight,
Freya my care—
Thoughtless one, remember the promised
 reward—
The castle finished,
The pledge falls due!
Hast thou forgot what was promised?
[*Bound, banned, and bridled by the break-
 less bond thou gav'st.*]

WOTAN.

Well wit I what they demanded,
They who the burg there did build.
By treaty tamed I the fierce pair,
To labor my lofty fort!
There stands it, thanks to the giants!
Let the price concern thee not.
[*Bound his honor for the castle's boon,
 Bound is Wotan by the spear-point's
 rune!*]

FRICKA.

Woe for thy laughing light heart!
Woe for thy easy folly!
Had I known of thy bond
A way I had found!
So lightly abandon, ye men, us poor
 women,
And, close and silent, without us
Alone with the giants deal ye!
So without shame, ye sinfully gave her,
Freia, my gentlest sister,
Gayly to shame have ye wed!
 What to ye, savage,
 Is holy and pure,
 Seek ye men but for might.!
[*Who works the gold to a ring
 Shall win the world for his own!*]

WOTAN.

Such desire did Fricka find strange
When she herself begged me to build?

FRICKA.

For my husband's truth had I care
 And sadly took I thought
 How to bind him by the heart
Though his soul yearned still for war—
 Lordliest castle,
 Lovingest home

PLAY VP. PIPER

BY JOSEPHINE PRESTON PEABODY

PLAY up, play up, my Piper,
 And play the timely song;
The song that never a worker hears
 Although his heart may long.
It's we are glad to listen here,
 Who have but Yea and Nay:
But would you only pipe to us
 The word we want to-day!

We heard your heart-break, Piper,
 And O, but it was like!
'Tis so, 'tis so—the ill winds blow,
 'Tis so the sorrows strike.
But could you only pipe to us
 The turning of the way,
And how it is you come at last
 To pipe again, to-day.

The broken hopes o' harvest,
 The wearing o' the rain,
The ailing of a little cheek—
 You make us weep again.
But tell us of the wage, man,
 You had for this hard day:
Play up, play up, dear Piper,
 And tell us why you play!

ILLUSTRATION FOR **PLAY UP PIPER**
BY JOSEPHINE PRESTON PEABODY, *SCRIBNER'S MAGAZINE*, AUGUST 1900

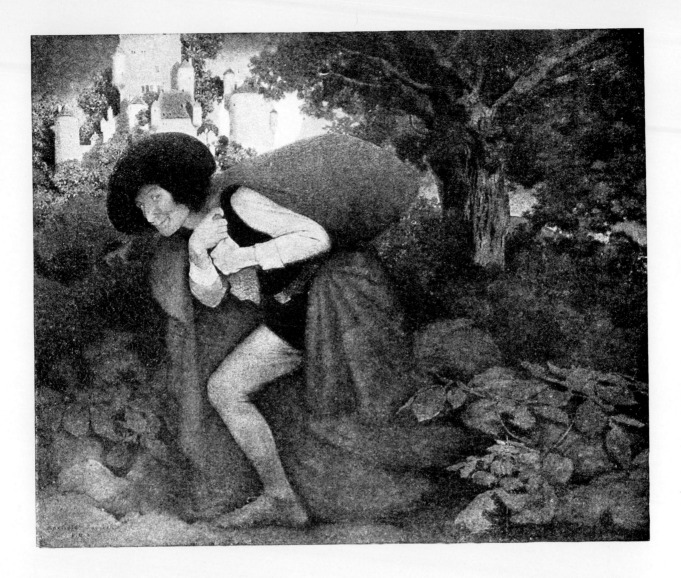

ILLUSTRATION FOR THE SAND MAN
BY ARTHUR MACY, *ST. NICHOLAS MAGAZINE*, NOVEMBER 1910

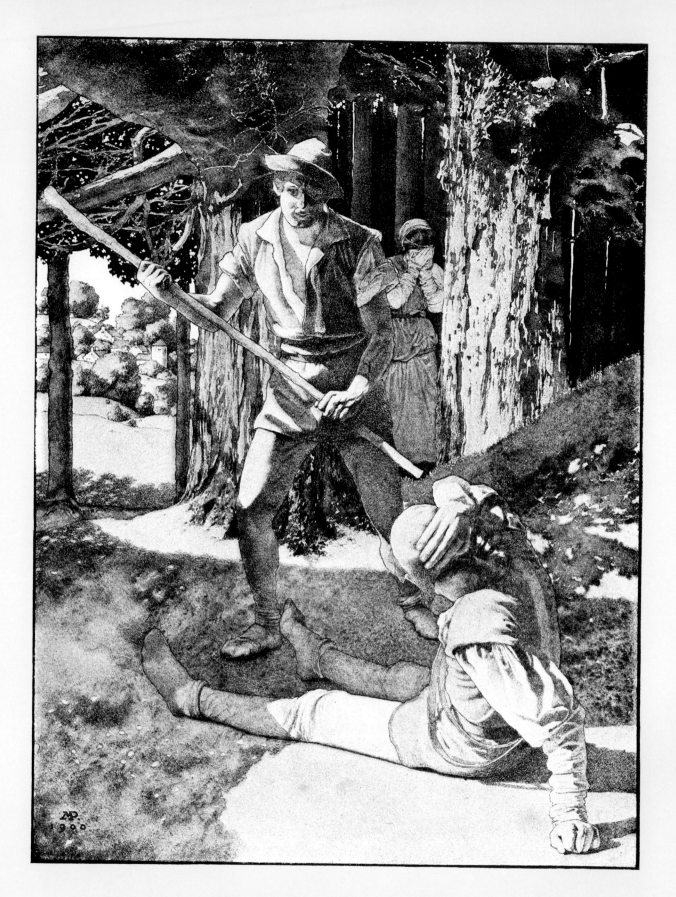

Oh, a quarter-staff is often rough.
ILLUSTRATION FOR A BALLAD IN LINCOLN GREEN
BY ALDIS DUNBAR, *ST. NICHOLAS MAGAZINE*, NOVEMBER 1900

One day the door opened . . . it was Ann Powel.
ILLUSTRATION FOR THE STORY OF ANN POWEL
BY ANNIE E. TYNAN, CENTURY MAGAZINE, JULY 1900

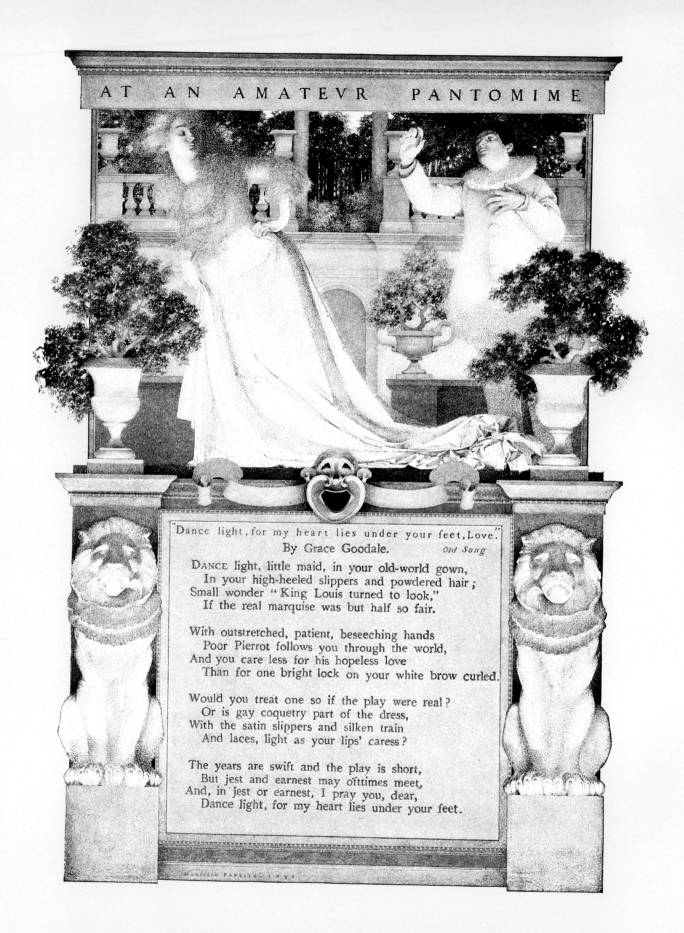

AT AN AMATEVR PANTOMIME

"Dance light, for my heart lies under your feet, Love."
By Grace Goodale. *Old Song*

DANCE light, little maid, in your old-world gown,
 In your high-heeled slippers and powdered hair;
Small wonder "King Louis turned to look,"
 If the real marquise was but half so fair.

With outstretched, patient, beseeching hands
 Poor Pierrot follows you through the world,
And you care less for his hopeless love
 Than for one bright lock on your white brow curled.

Would you treat one so if the play were real?
 Or is gay coquetry part of the dress,
With the satin slippers and silken train
 And laces, light as your lips' caress?

The years are swift and the play is short,
 But jest and earnest may ofttimes meet,
And, in jest or earnest, I pray you, dear,
 Dance light, for my heart lies under your feet.

ILLUSTRATION FOR **AT AN AMATEUR PANTOMIME**
BY GRACE GOODALE, *SCRIBNER'S MAGAZINE*, NOVEMBER 1898

BE GOOD

ELLEN

HER BOOK

BOOKPLATE FOR ELLEN BIDDLE SHIPMAN
PUBLISHED AS AN ILLUSTRATION FOR A MASTER OF MAKE-BELIEVE
BY CHRISTIAN BRINTON, *CENTURY MAGAZINE*, JULY 1912

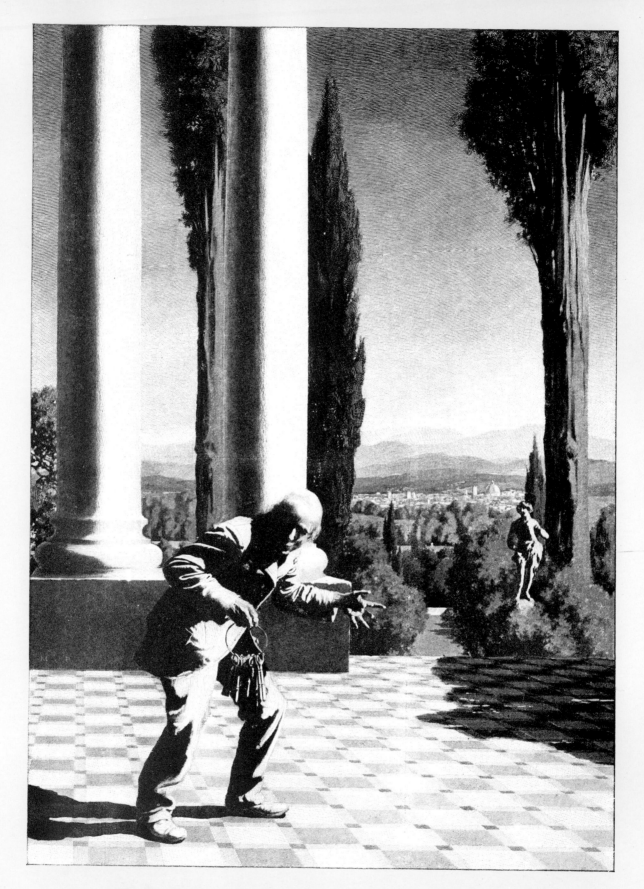

"The Duchess's apartments are beyond," said the old man.
ILLUSTRATION FOR THE DUCHESS AT PRAYER
BY EDITH WHARTON, *SCRIBNER'S MAGAZINE*, AUGUST 1900

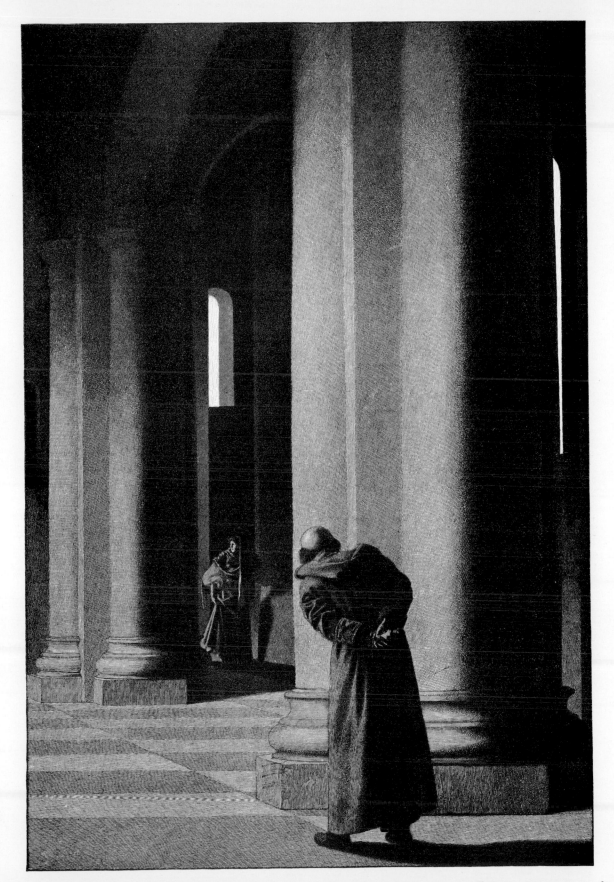

He was the kind of man who brings a sour mouth to the eating of the sweetest apple.
ILLUSTRATION FOR THE DUCHESS AT PRAYER
BY EDITH WHARTON, *SCRIBNER'S MAGAZINE*, AUGUST 1900

DOUBLE-PAGE ILLUSTRATION FOR CHRISTMAS EVE
BY EDNAH PROCTOR CLARKE, CENTURY MAGAZINE, DECEMBER 1898

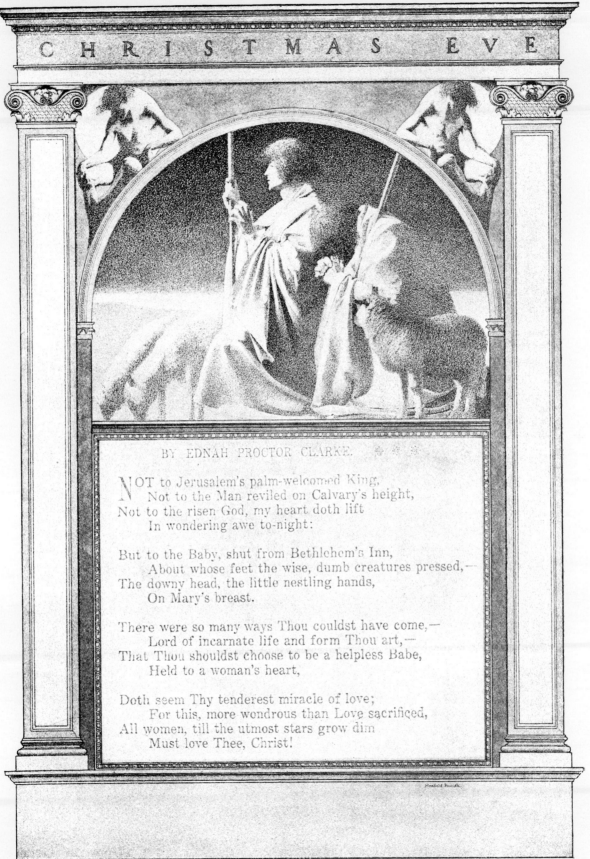

CHRISTMAS EVE

BY EDNAH PROCTOR CLARKE. * * *

NOT to Jerusalem's palm-welcomed King,
　　Not to the Man reviled on Calvary's height,
Not to the risen God, my heart doth lift
　　In wondering awe to-night:

But to the Baby, shut from Bethlehem's Inn,
　　About whose feet the wise, dumb creatures pressed,—
The downy head, the little nestling hands,
　　On Mary's breast.

There were so many ways Thou couldst have come,—
　　Lord of incarnate life and form Thou art,—
That Thou shouldst choose to be a helpless Babe,
　　Held to a woman's heart,

Doth seem Thy tenderest miracle of love;
　　For this, more wondrous than Love sacrificed,
All women, till the utmost stars grow dim
　　Must love Thee, Christ!

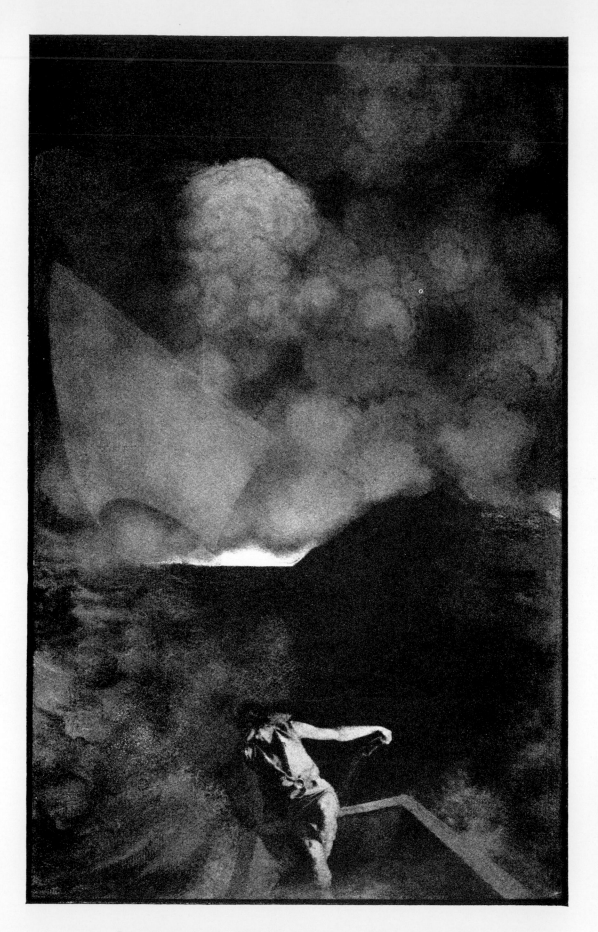

ILLUSTRATION FOR STORM SONG OF THE NORSEMEN
BY MILDRED I. McNEAL, *CENTURY MAGAZINE*, JANUARY 1901

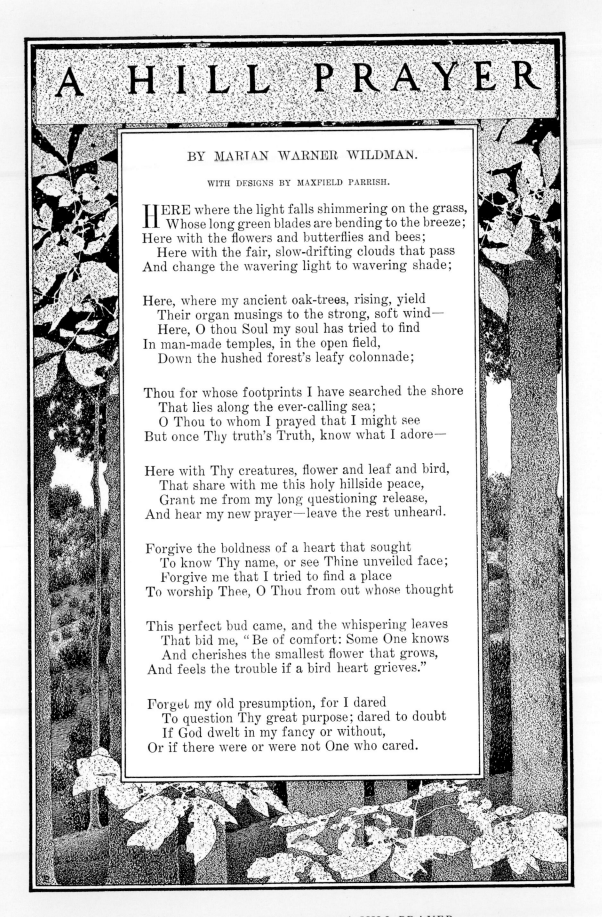

A HILL PRAYER

BY MARIAN WARNER WILDMAN.

WITH DESIGNS BY MAXFIELD PARRISH.

HERE where the light falls shimmering on the grass,
　　Whose long green blades are bending to the breeze;
Here with the flowers and butterflies and bees;
　　Here with the fair, slow-drifting clouds that pass
And change the wavering light to wavering shade;

Here, where my ancient oak-trees, rising, yield
　　Their organ musings to the strong, soft wind—
　　Here, O thou Soul my soul has tried to find
In man-made temples, in the open field,
　　Down the hushed forest's leafy colonnade;

Thou for whose footprints I have searched the shore
　　That lies along the ever-calling sea;
　　O Thou to whom I prayed that I might see
But once Thy truth's Truth, know what I adore—

Here with Thy creatures, flower and leaf and bird,
　　That share with me this holy hillside peace,
　　Grant me from my long questioning release,
And hear my new prayer—leave the rest unheard.

Forgive the boldness of a heart that sought
　　To know Thy name, or see Thine unveiled face;
　　Forgive me that I tried to find a place
To worship Thee, O Thou from out whose thought

This perfect bud came, and the whispering leaves
　　That bid me, "Be of comfort: Some One knows
　　And cherishes the smallest flower that grows,
And feels the trouble if a bird heart grieves."

Forget my old presumption, for I dared
　　To question Thy great purpose; dared to doubt
　　If God dwelt in my fancy or without,
Or if there were or were not One who cared.

TITLE PAGE ILLUSTRATION FOR A HILL PRAYER
BY MARIAN WARNER WILDMAN, CENTURY MAGAZINE, DECEMBER 1899

And even while I prayed, I feared to see,
 Lest lifted veil should show an empty shrine;
 I dared to call my dreams of beauty mine,
And half believed they were too fair to be.

My dreams too fair to be? The redwing's notes
 Up from the marsh in breezy freshness ring;
 Among the willow-trees the vireos sing
Their sweet, repeated warblings; yonder floats
 A snow of petals from a hawthorn-tree;

Subtile and sweet the wild grape-blossoms throw
 Their meed of perfume to the breath of May,
 And every sluggish little bud that lay
Inert and joyless through the night of snow
 Bursts, like my heart, with springtime ecstasy.

My dreams too fair to be? O Thou whose love
 Dreams beauty into being, makes it true,—
 Those far white clouds that float across the blue,
The sweet spring day here, and that hidden dove,—

I ask no more to see, to understand;
 Not yet, O God, not yet the unveiled face!
 Let me through many springtimes search the grace
In one of these the marvels of Thy hand.

What Thou art, I may never comprehend,
 Or whether Love or Law or God or Power;
 What I am, in the passing of this hour
Has ceased to matter: here my strivings end,
 And here, in blessing Thee, my soul is blest.

Not for some far-off heaven's higher bliss,
 Not for some destiny that waits for me,
 Not for dream-gloried worlds that are to be,
But for the simple loveliness of this,
 Close to this throbbing hillside's fragrant breast,

I love Thee, with a beauty-broken heart,
And worship Thee, be whatsoe'er Thou art.

PAGE DESIGN FOR A HILL PRAYER
BY MARIAN WARNER WILDMAN, CENTURY MAGAZINE, DECEMBER 1899

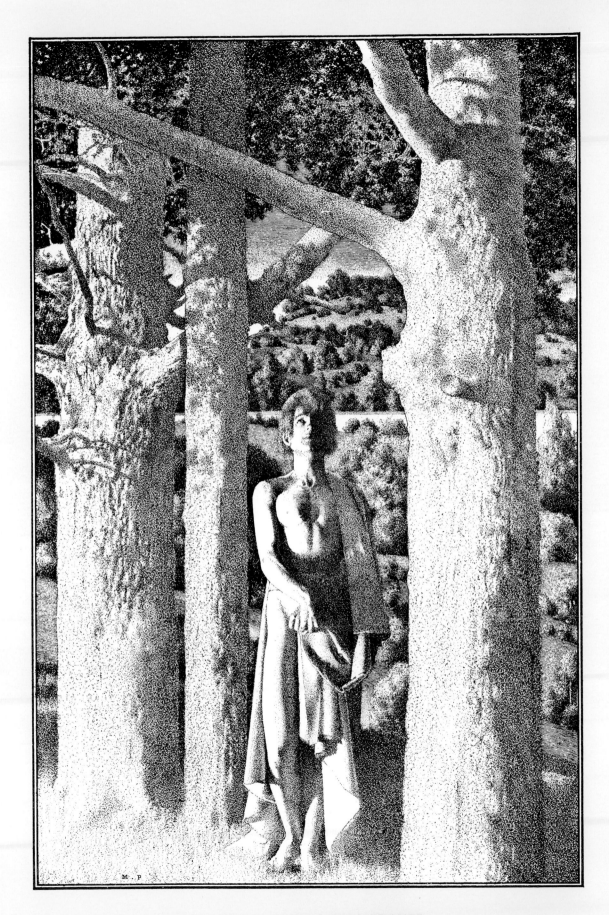

ILLUSTRATION FOR A HILL PRAYER
BY MARIAN WARNER WILDMAN, *CENTURY MAGAZINE*, DECEMBER 1899

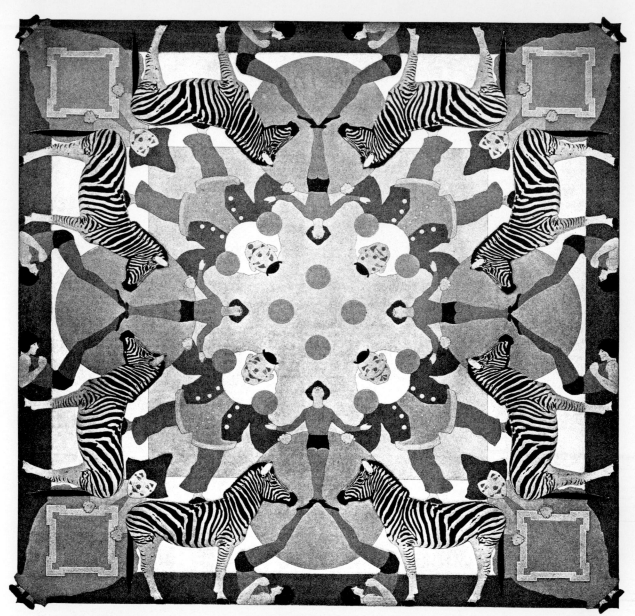

A Circus Bedquilt

By Maxfield Parrish

THE effectiveness of this design depends on a careful arrangement of the various lights and darks and colors. Otherwise it is intended to represent a circus. The color scheme is quite important, and the thing to be borne in mind, first of all, is a harmony of color. All harsh and vivid colors are to be avoided. When it is finished one might almost dip the whole thing in coffee in order that the colors might be enriched a little and made to "hang together." Or the desired result might be obtained if the different colors were pieces cut from old clothes: wash goods such as old skirts and shirtwaists of linen; things which have been washed a number of times. They are sure to be faded and mellow in tone, and if unfit for further wear would be just the thing for the quilt. When you call a color by name it may mean a great many different shades of that color to as many different people, but if one will keep in mind that all the colors must be old and faded one cannot go far wrong.

The lightest part of the entire design is the border back of the zebras; that should be pure white. Next in scale come the collars or ruffs of the clowns standing on the zebras; these ruffs should be a little bit darker than the white of the border, say an old white made yellow by time. The white of the zebras should be a little darker than the ruffs, and the big square background a wee bit darker still. Then the paper hoops the clowns are holding should be just a shade darker than the square background. So these five things are to be five different shades of white, running from a pure spick-and-span white to a dull ivory white, almost a gray, in fact. One may think it is hardly worth while to insist on such subtle little differences, but it really counts a lot in the end.

The buttons on the clowns might be large, flat, wooden ones, covered with cloth, and as they are comparatively small they might be rather lively in color, say yellow or pale orange. The dark border is an old blue. The acrobats on their backs are green, a blue-green to go well against the old blue border, and the figures they are holding are a lighter blue. The trunks of the acrobats should be quite dark, and a purple at that, provided it has been through the laundry. The flesh tints should be a pale warm pink, like a pink window-curtain which has seen much sun. The marks on the clowns' faces should be a pale vermilion. The hair of those who have any should be a wine color. The balls in the centre are buff. The derby hats of the clowns, the zebras' stripes, hoofs and tails are black, and a washed-out black will look better than a new one. Down in the corners the clowns have a garment of gray: they hold a lavender square with a buff border worked around the edges with white. In the squares go the monograms of the owners. The clowns' stockings are light gray, and their shoes, and those of the clowns on the zebras, are a dull rose. These zebra clowns have turquoise-blue coats, buff vests (a little darker than the balls) with lines worked in white around the bottom, and their trousers are a gray-blue, lighter than their coats. So much for the color.

The zebras will be the hardest things to do, because the stripes should be rendered accurately. But the other figures ought not to be difficult, as they are cut out by doubling over and cutting one side, as children cut out things from paper. The various parts may be outlined or not with appliqué, as you think best.

It is impossible for us to supply any patterns for this quilt. All that can be told about it is told here.

ILLUSTRATION FOR **A CIRCUS BEDQUILT**

The Ladies' Home Journal Bridal Number, March 1905

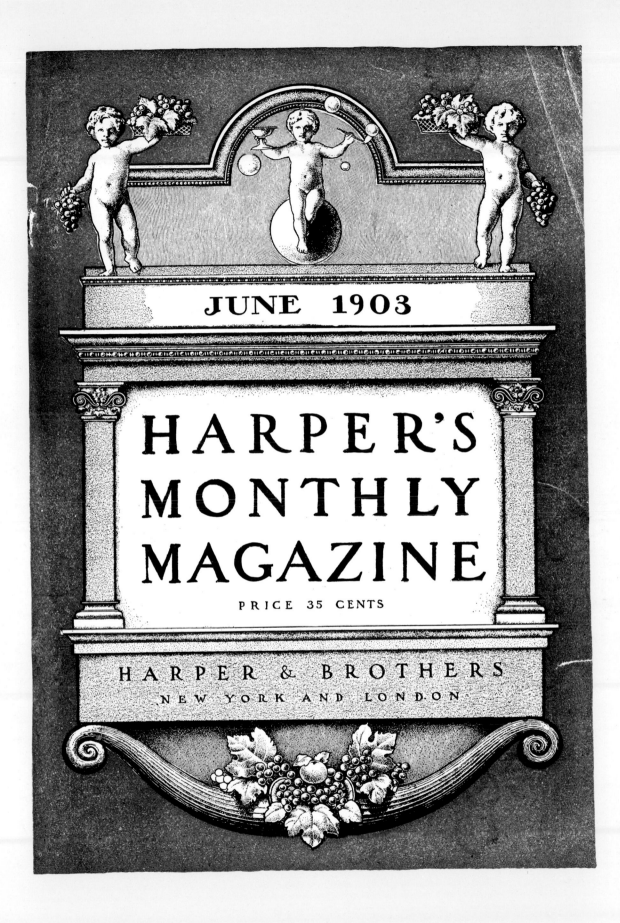

FRONT COVER ILLUSTRATION FOR *HARPER'S MONTHLY MAGAZINE*, JUNE 1903

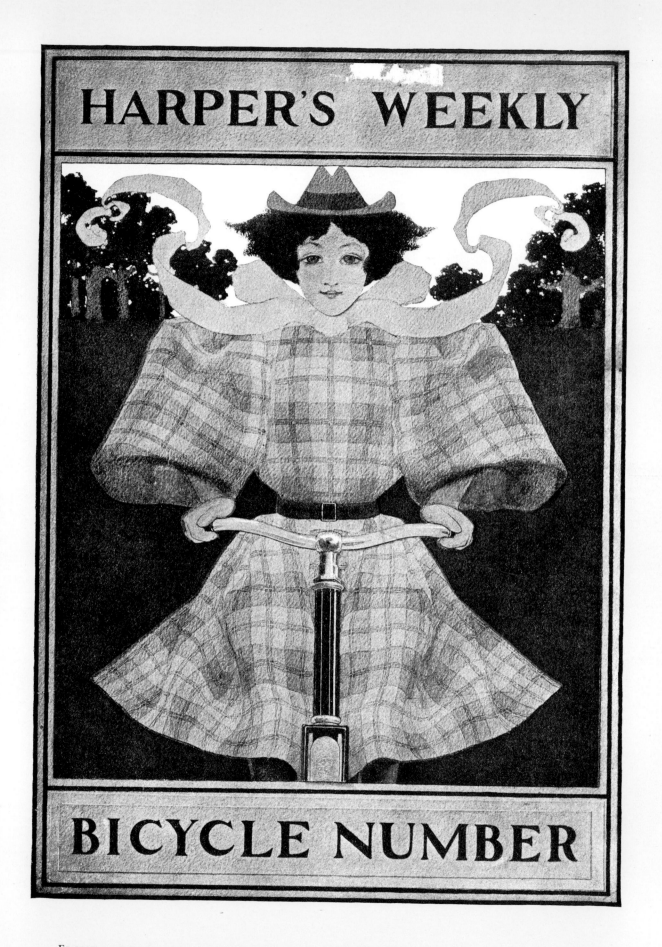

FRONT COVER ILLUSTRATION FOR *HARPER'S WEEKLY* BICYCLE NUMBER, APRIL 11, 1896

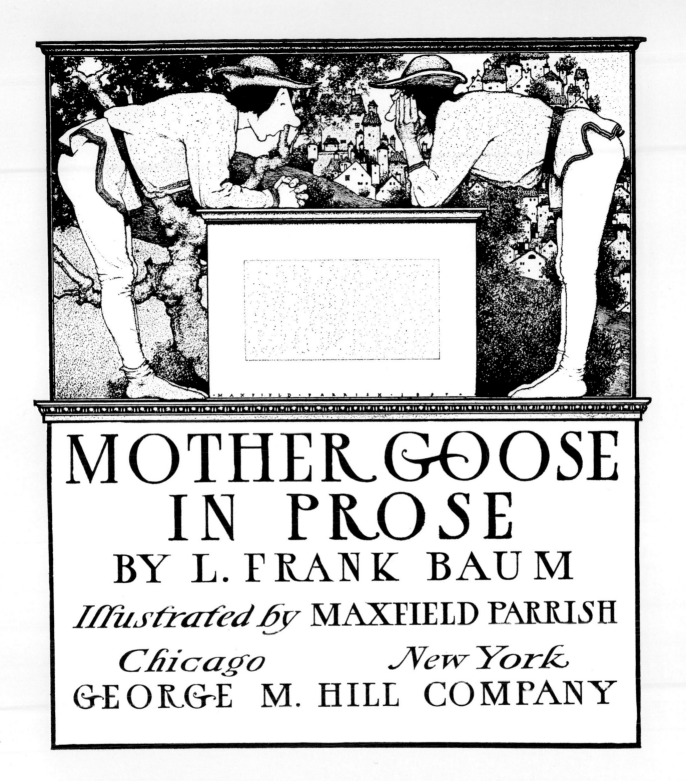

MOTHER GOOSE
IN PROSE
BY L. FRANK BAUM

Illustrated by MAXFIELD PARRISH

Chicago *New York*
GEORGE M. HILL COMPANY

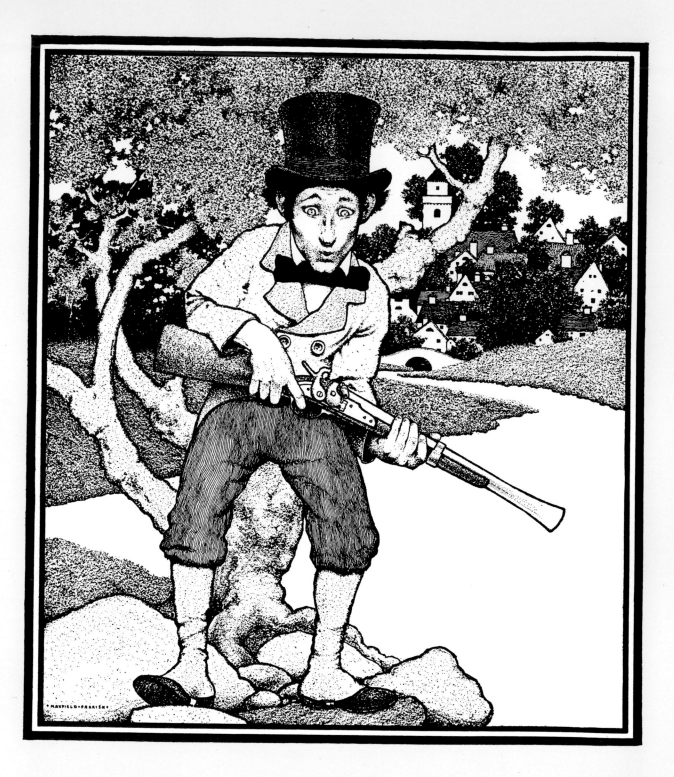

The Little Man and His Little Gun

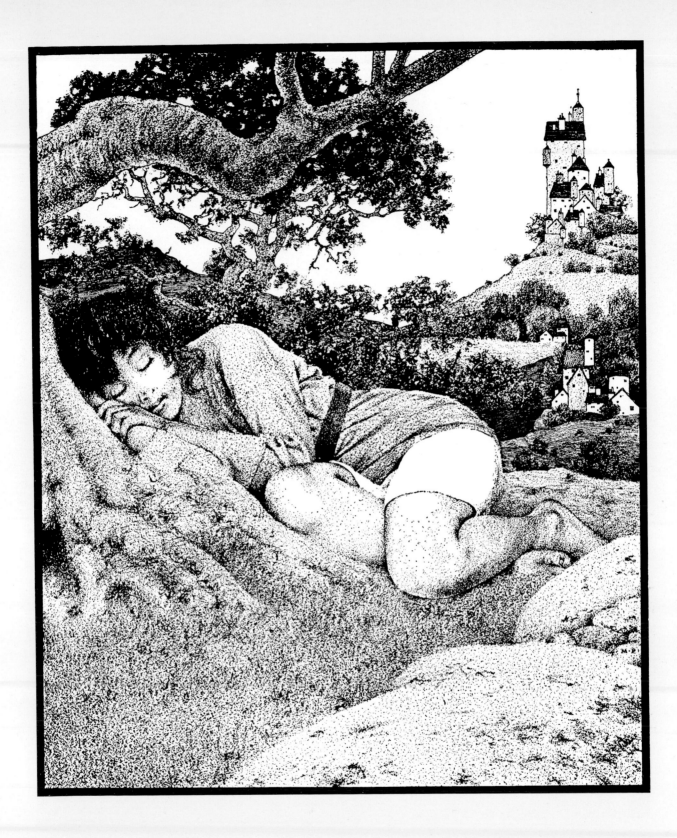

Little Boy Blue

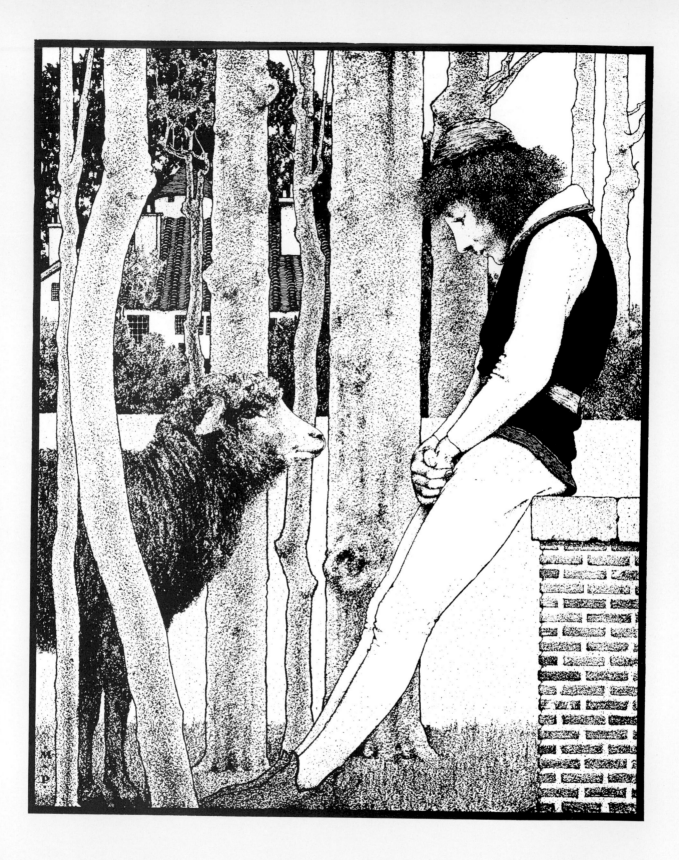

The Black Sheep

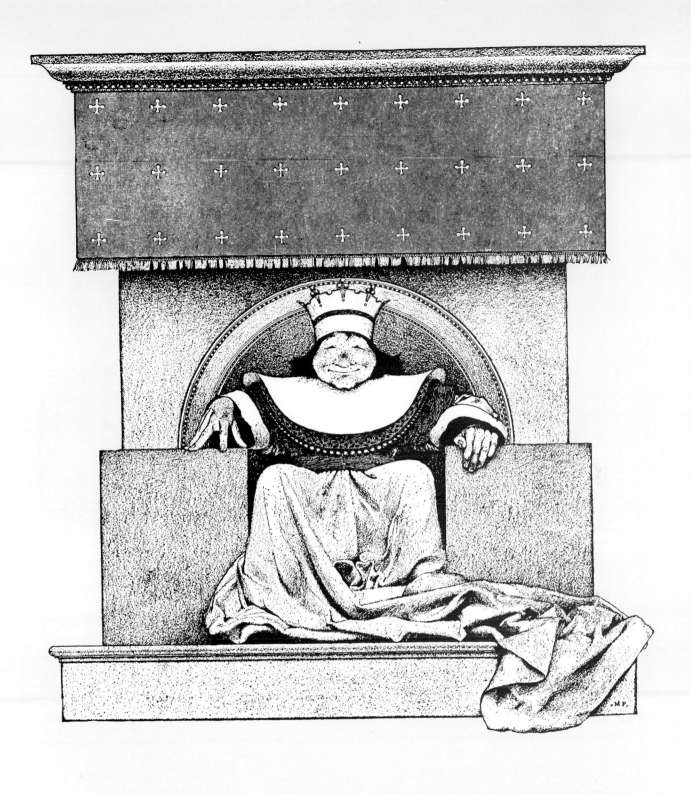

Old King Cole

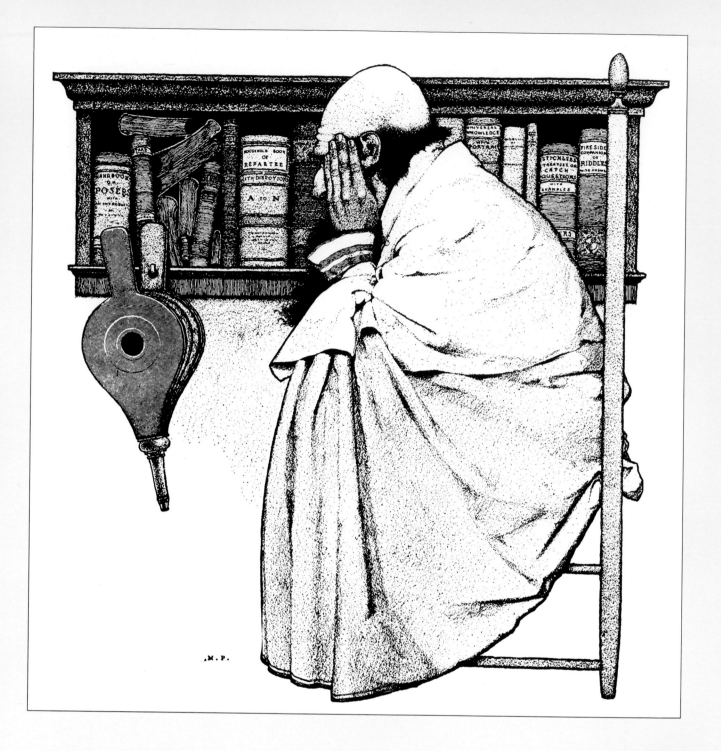

The Wond'rous Wise Man

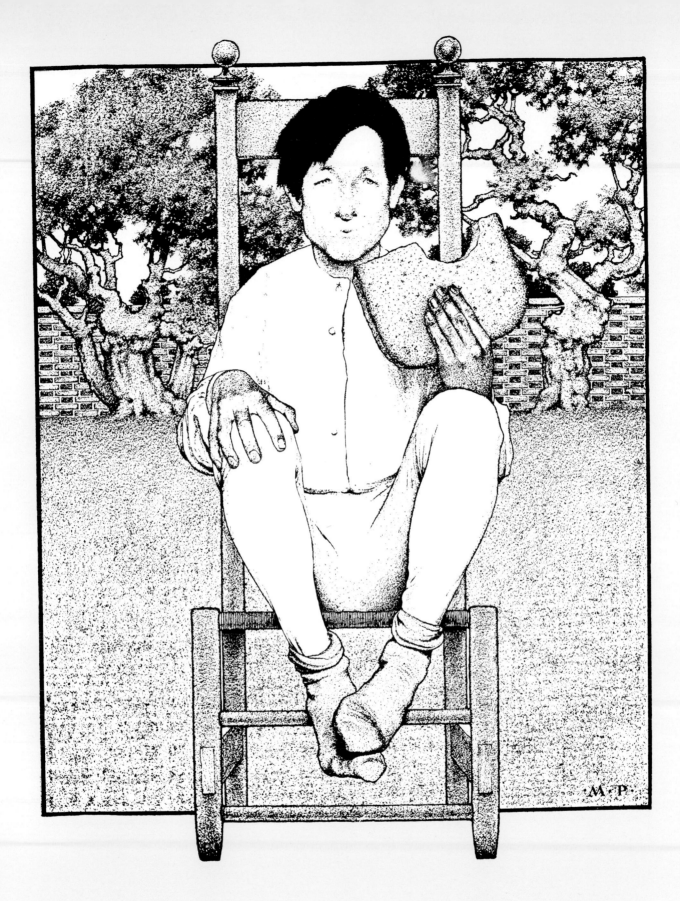

Tommy Tucker

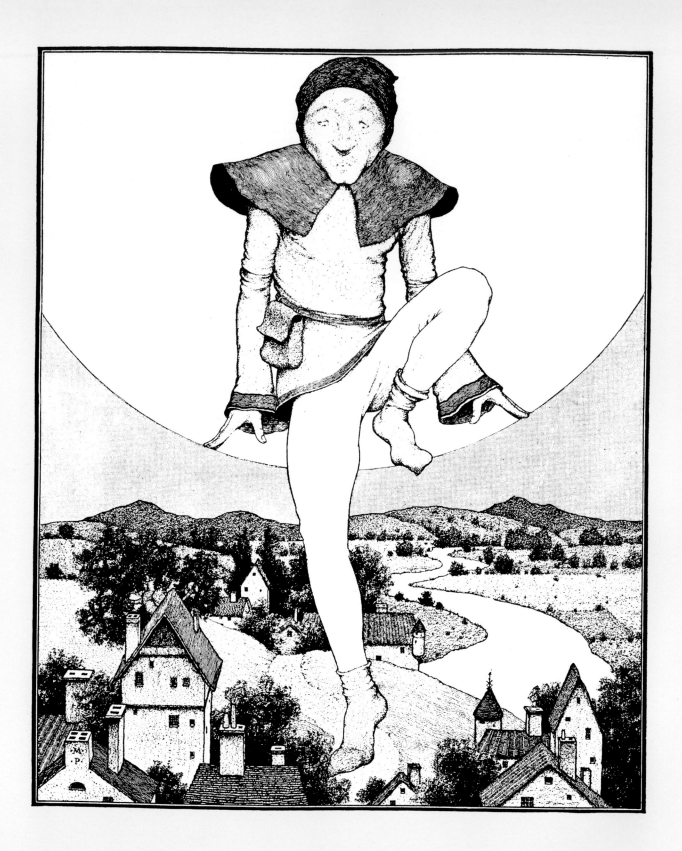

The Man in the Moon

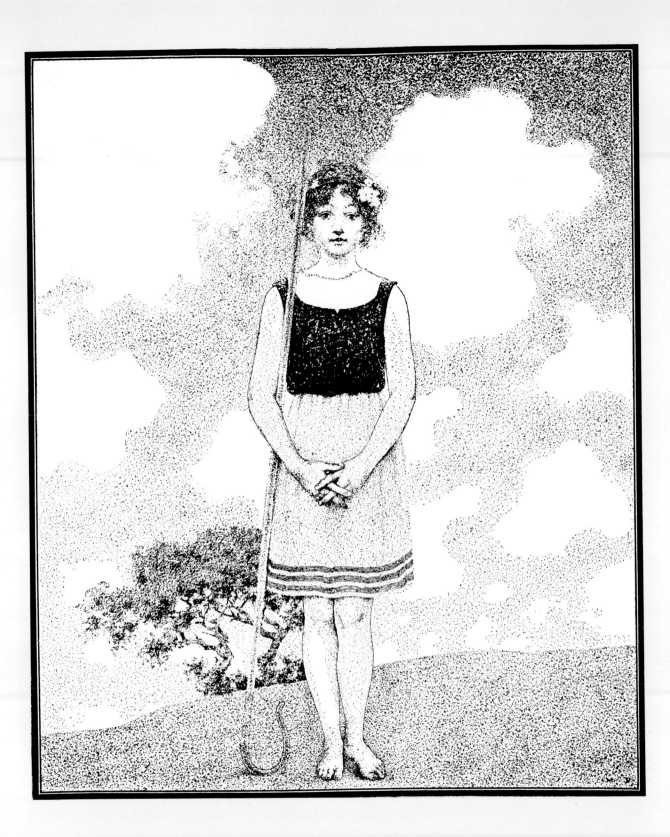

Little Bo-Peep

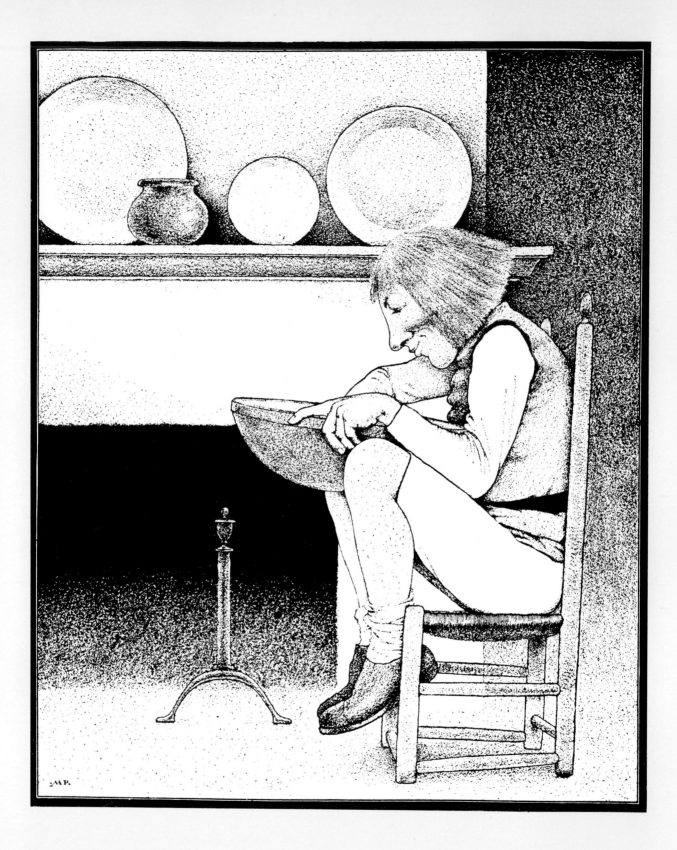

Jack Horner

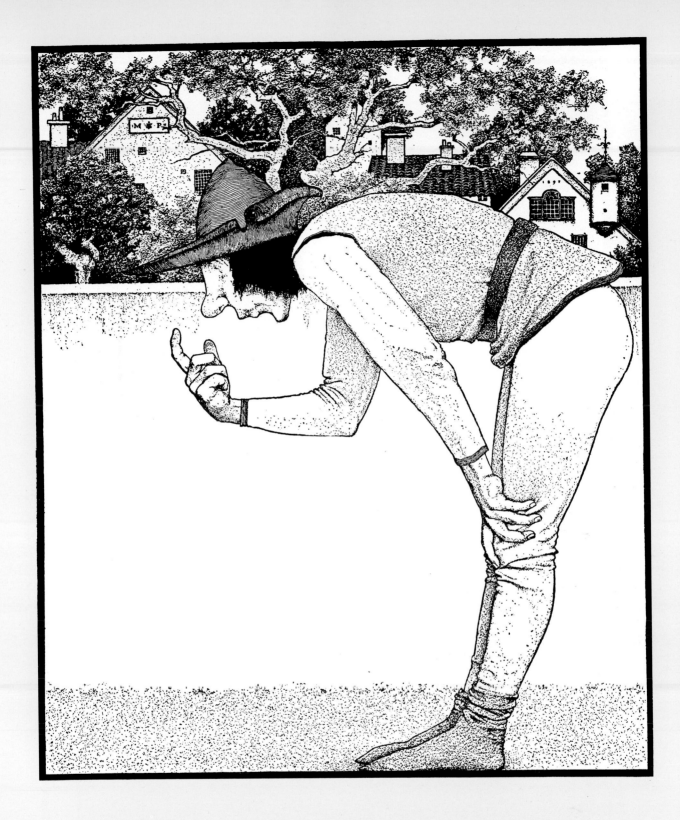

Tom, the Piper's Son

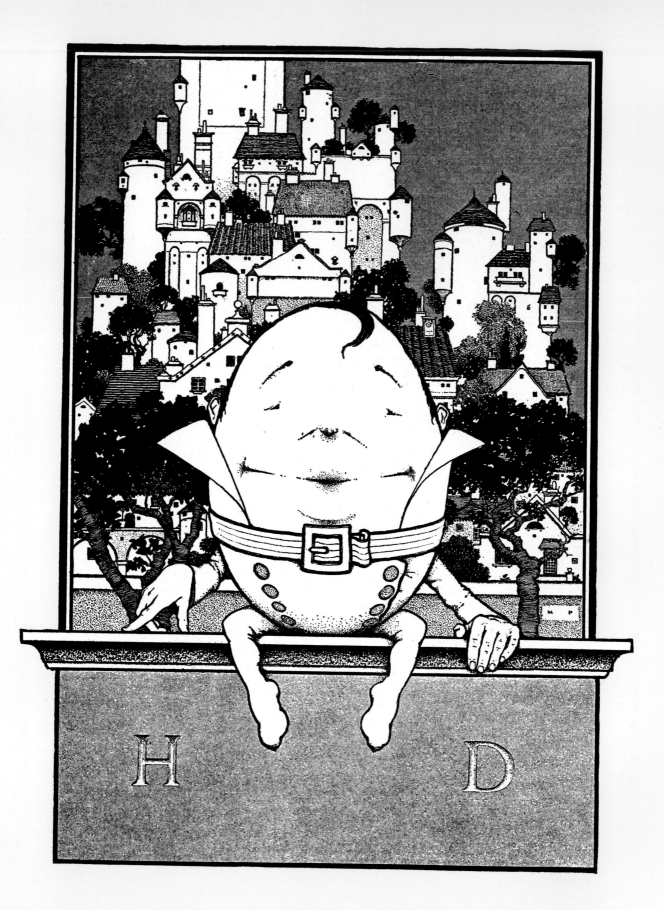

Humpty Dumpty

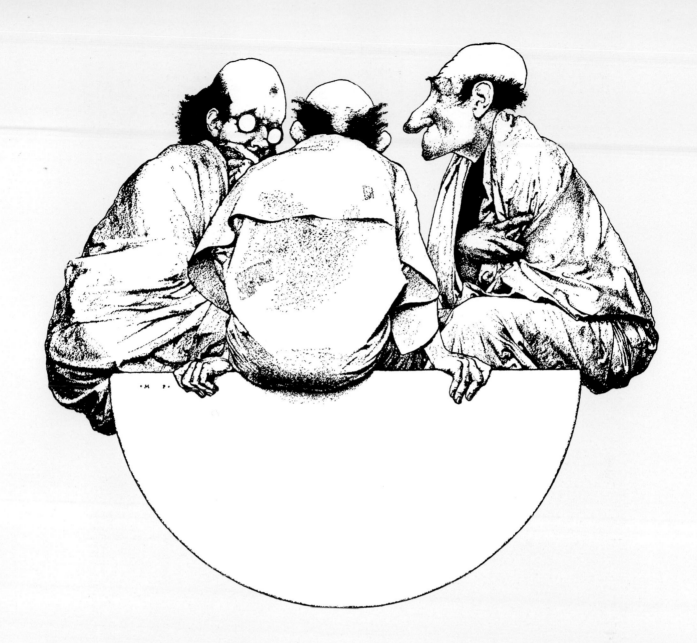

Three Wise Men of Gotham

ILLUSTRATIONS FOR

"ITS WALLS WERE AS OF JASPER"

BY KENNETH GRAHAME

SCRIBNER'S MAGAZINE, AUGUST 1897

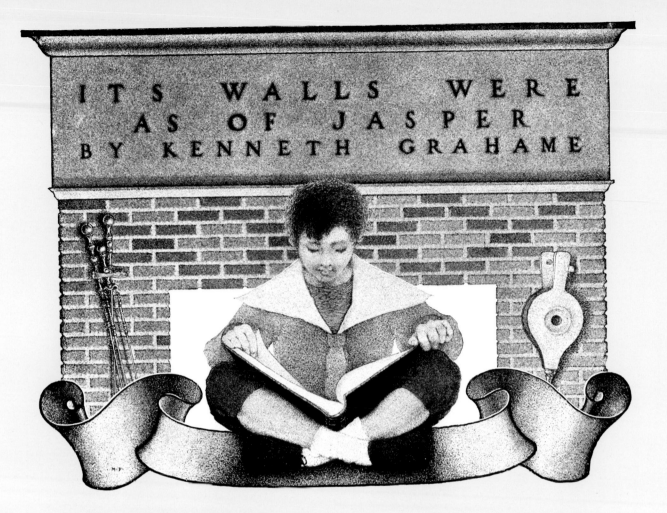

ITS WALLS WERE
AS OF JASPER
BY KENNETH GRAHAME

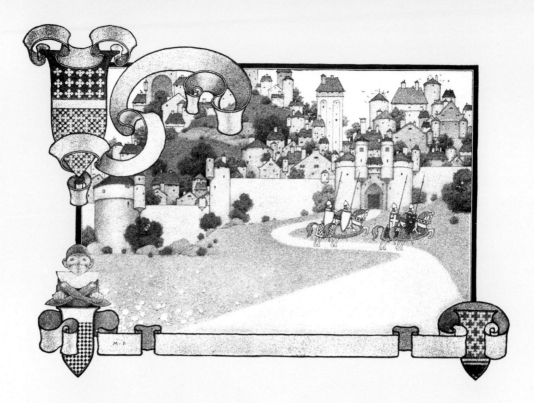

*A very fascinating background it was, and held a great deal,
though so tiny.*

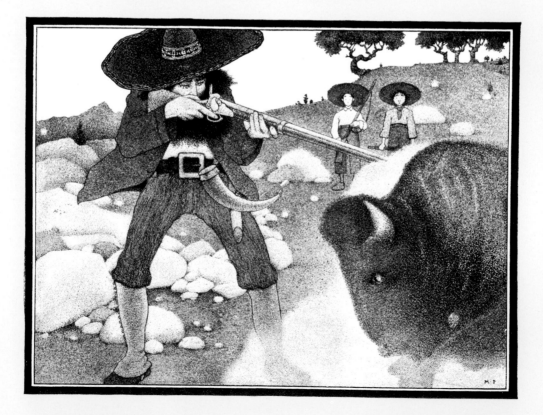

*Edward was the stalwart, bearded figure, . . . who undauntedly
discharged the fatal bullet into the shoulder of the great bull bison.*

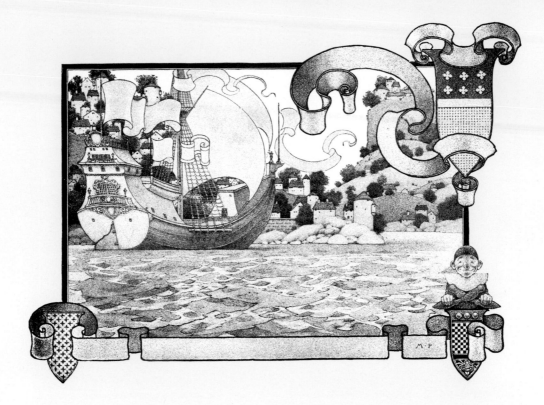

The hill on one side descended to water, . . .
and a very curly ship lay at anchor.

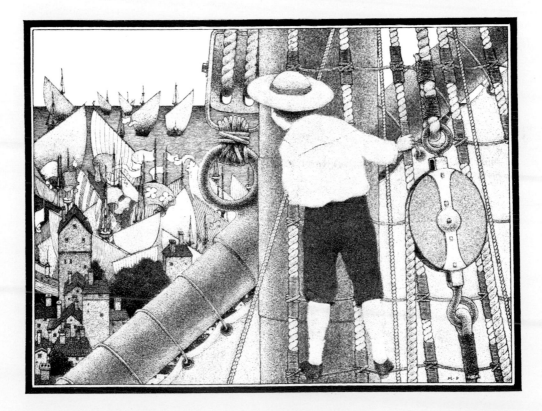

You could just see over the headland, and take in at your ease
the life and bustle of the port.

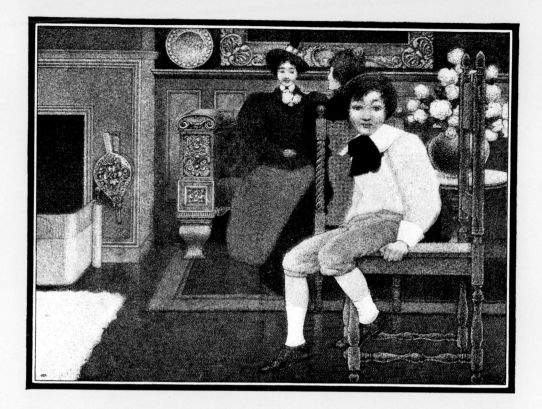

*In ten seconds they had their heads together
and were hard at it talking clothes.*

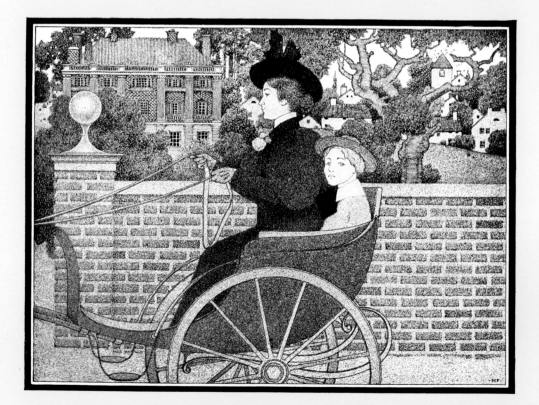

*As we eventually trundled off, it seemed to me
that the utter waste of that afternoon . . . could never be made up.*

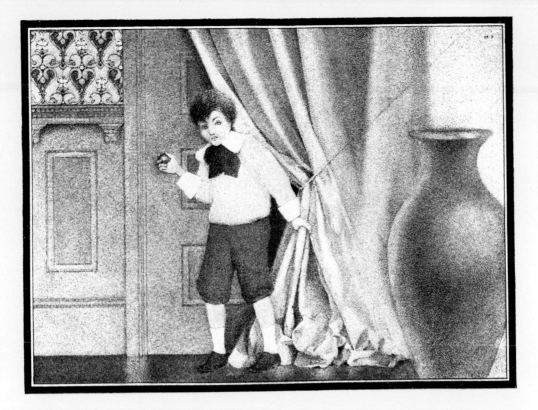

I glanced carefully around. They were still deep in clothes,
both talking together.

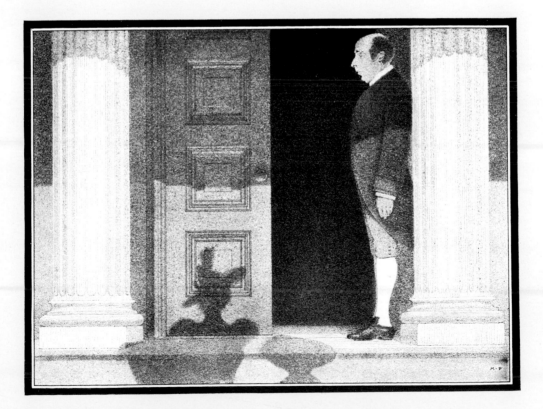

A grave butler who . . . pretended to have entirely forgotten
his familiar intercourse with you.

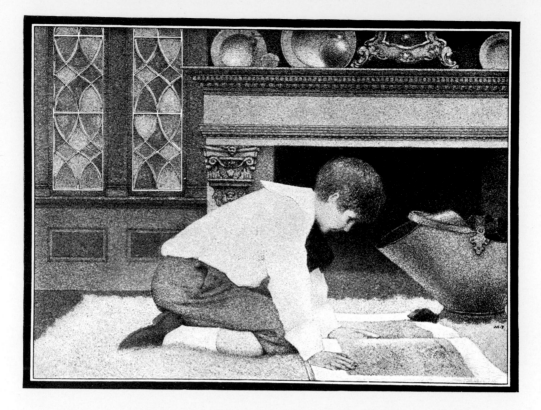

When I got the book open, there was a difficulty at first in making the great stiff pages lie down.

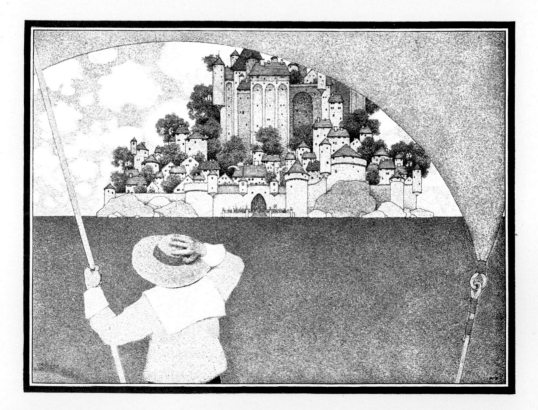

From the deck I should see the little walled town recede and sink and grow dim.

ILLUSTRATIONS FOR

KNICKERBOCKER'S HISTORY
OF NEW YORK

BY WASHINGTON IRVING

PUBLISHED BY R. H. RUSSELL, NEW YORK, 1900

KNICKERBOCKER'S HISTORY OF NEW YORK
BY WASHINGTON IRVING

The whole Embellish'd by *Eight Pictures* from the Hand of
MAXFIELD PARRISH, ESQ^{RE.}

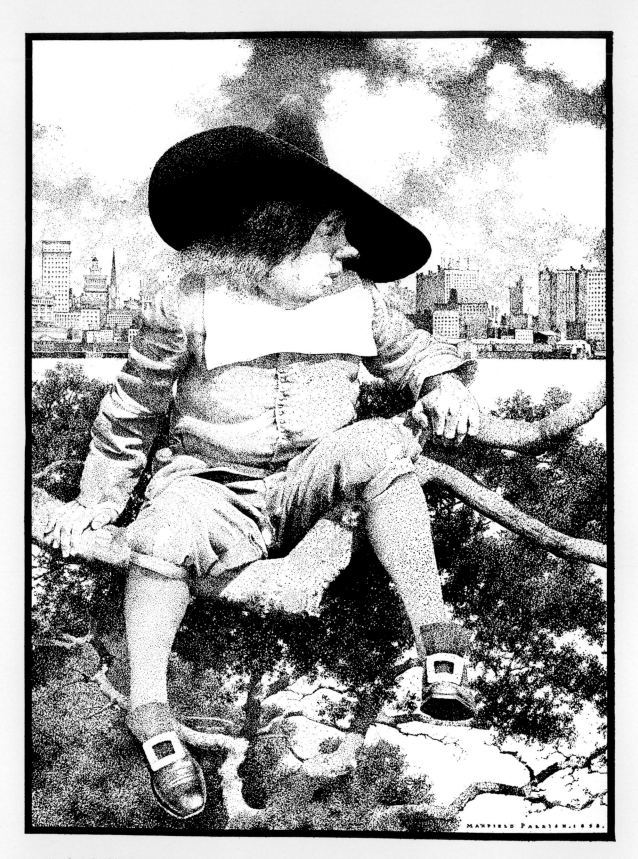

And Oloffe bethought him, and he hastened and climbed up to the top of one of the tallest trees, and saw that the smoke spread over a great extent of country; and, as he considered it more attentively, he fancied that the great volume of smoke assumed a variety of marvellous forms, where in dim obscurity he saw shadowed out palaces and domes and lofty spires.

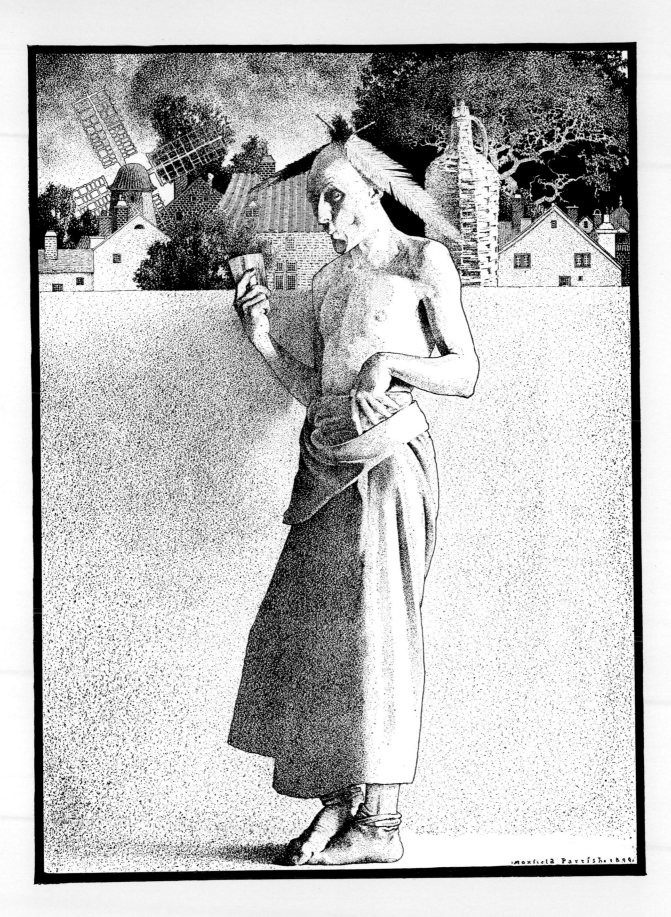

They introduced among them rum, gin, and brandy,
and the other comforts of life.

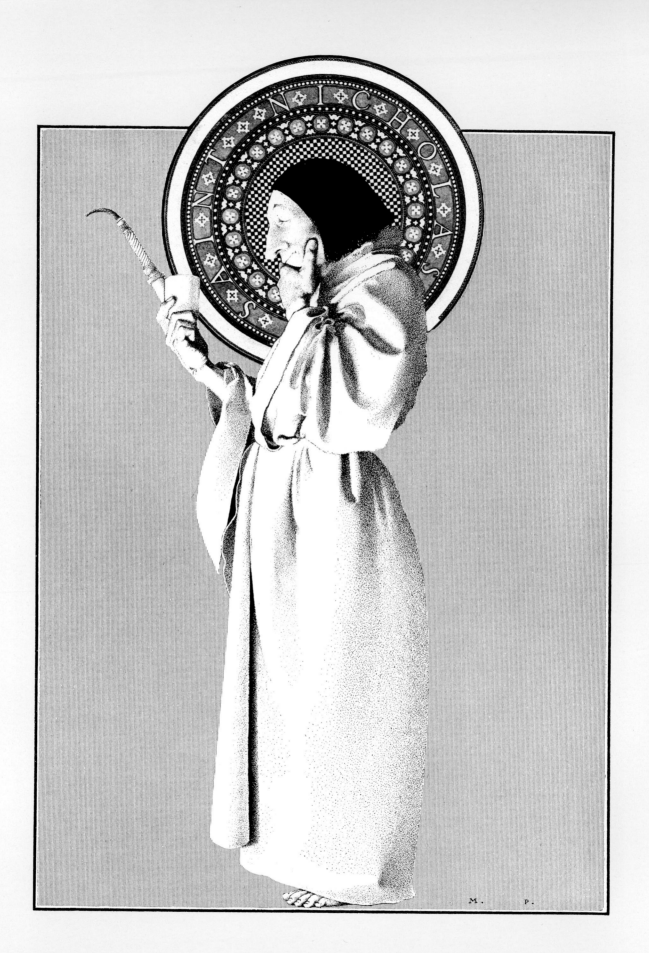

Saint Nicholas

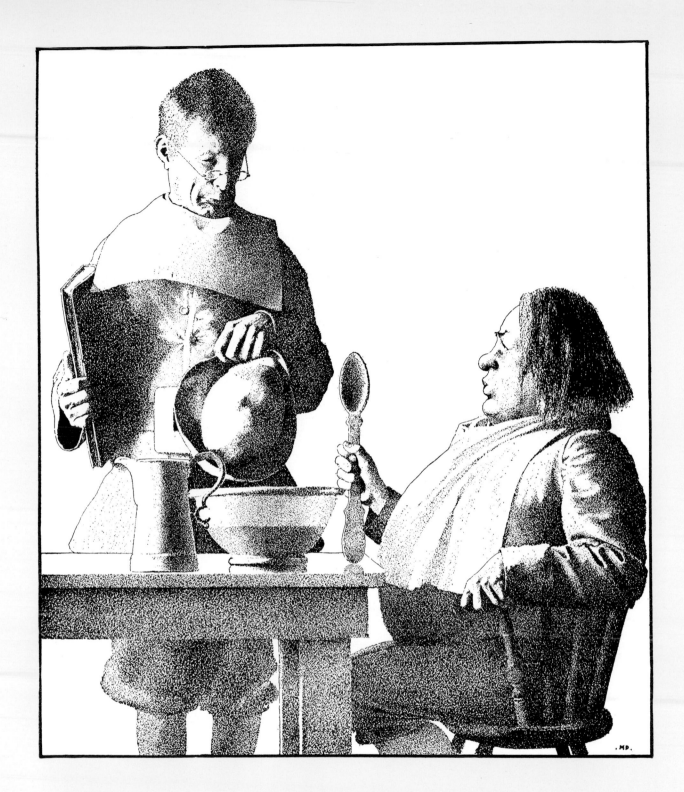

WOUTER VAN TWILLER. *The morning after he had been installed in office, and at the moment that he was making his breakfast from a prodigious earthen dish, filled with milk and Indian pudding, he was interrupted by the appearance of Wandle Schoonhoven, a very important old burgher of New Amsterdam.*

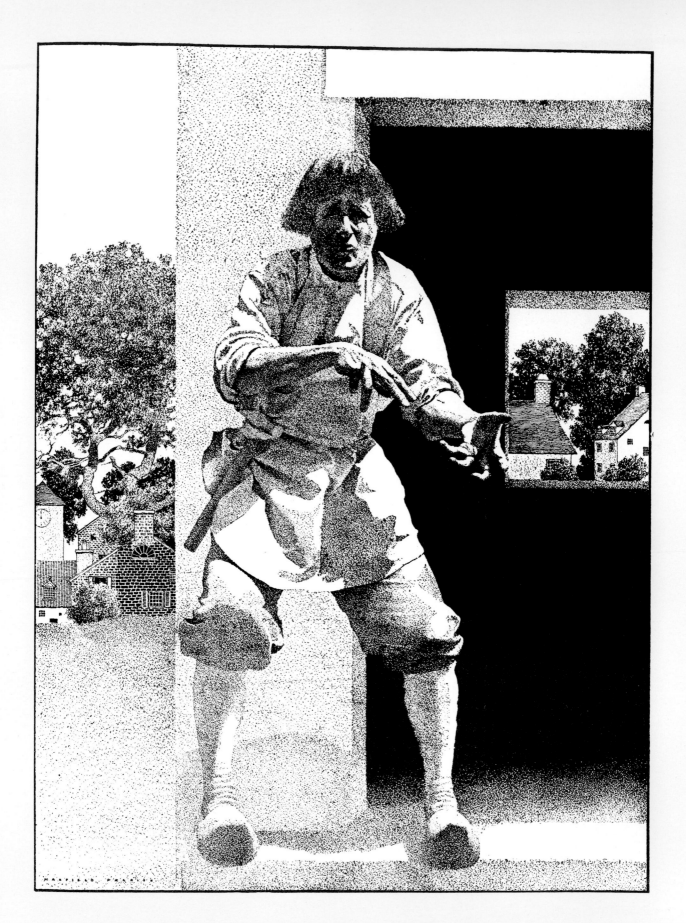

Blacksmiths . . . suffered their own fires to go out,
while they blew the bellows and stirred up the fires of faction.

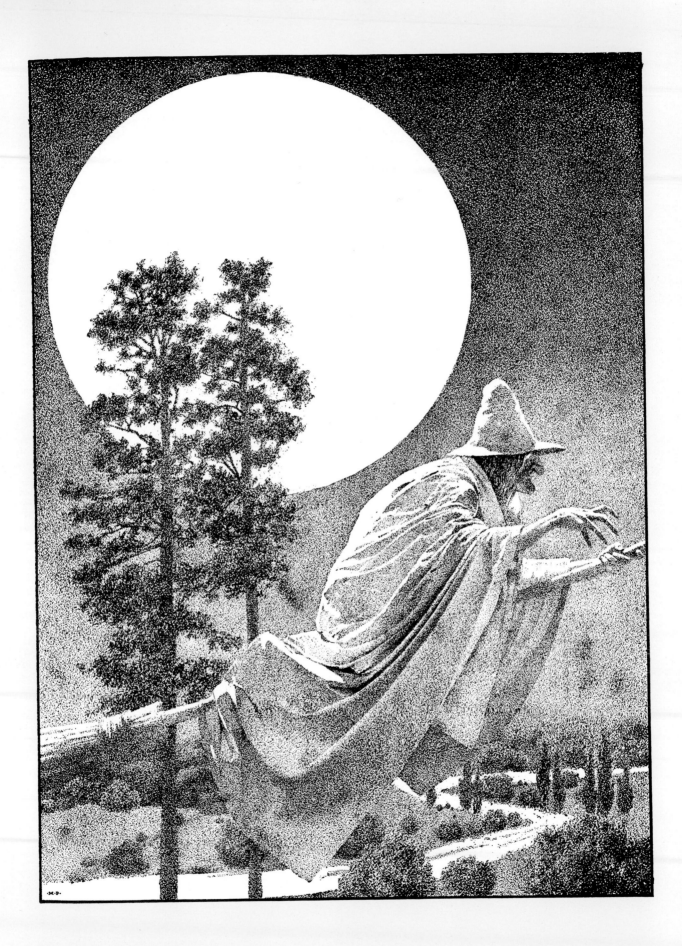

Concerning witchcraft.

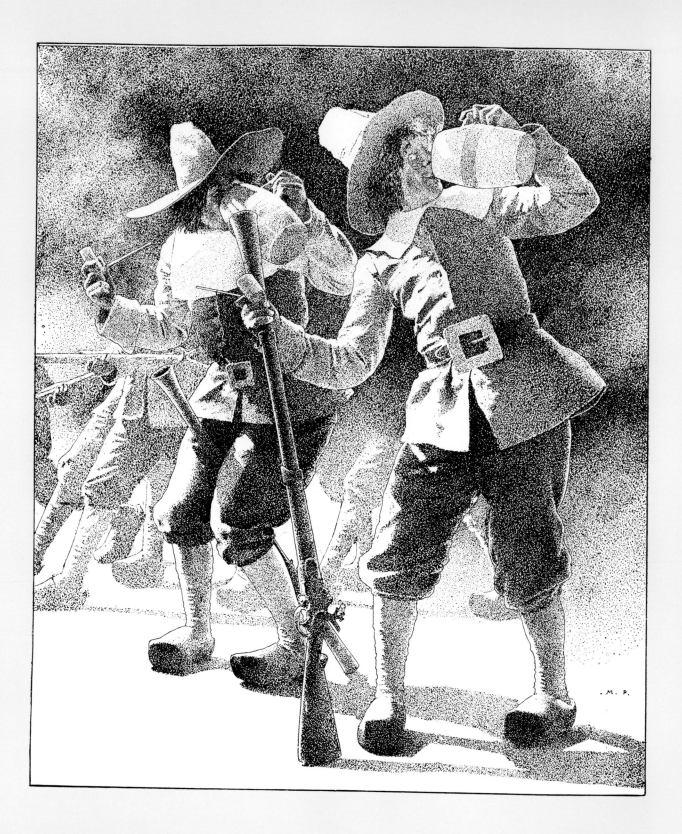

A phalanx of oyster-fed Pavonians . . . who had remained behind
to digest the enormous dinner they had eaten.

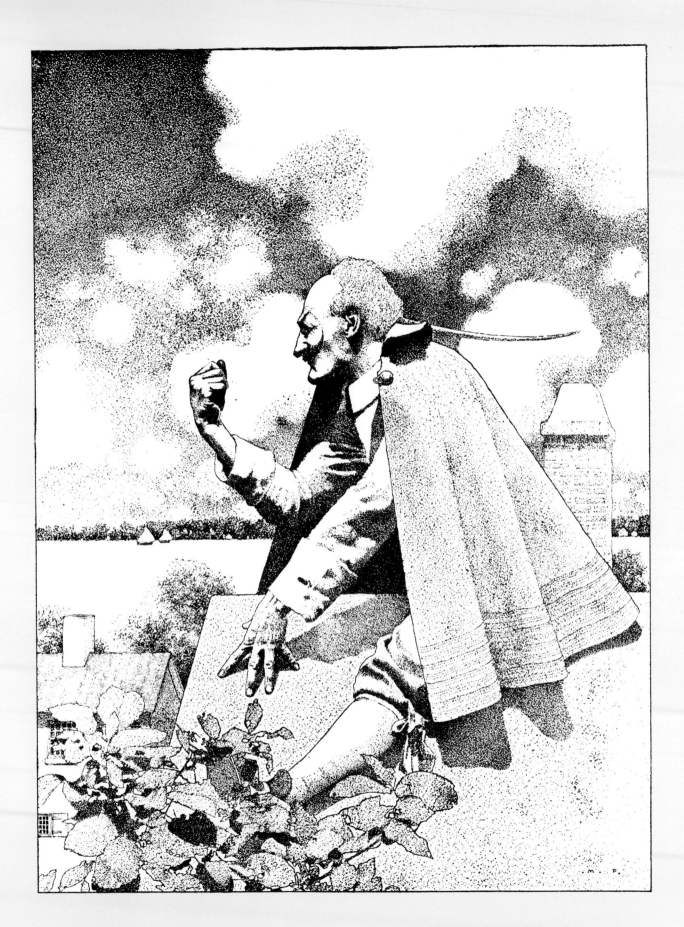

The first movement of the governor . . . was to mount to the roof, whence he contemplated with rueful aspect the hostile squadron.

ILLUSTRATIONS FOR

THE GOLDEN AGE

BY KENNETH GRAHAME

ORIGINALLY PUBLISHED BY JOHN LANE: THE BODLEY HEAD

LONDON AND NEW YORK, 1899

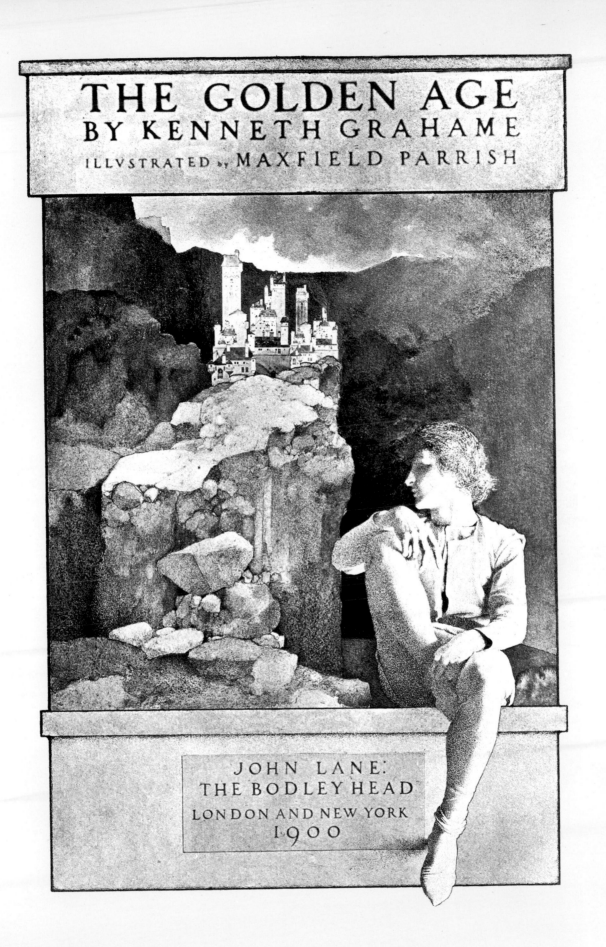

THE GOLDEN AGE
BY KENNETH GRAHAME
ILLVSTRATED by MAXFIELD PARRISH

JOHN LANE:
THE BODLEY HEAD
LONDON AND NEW YORK
1900

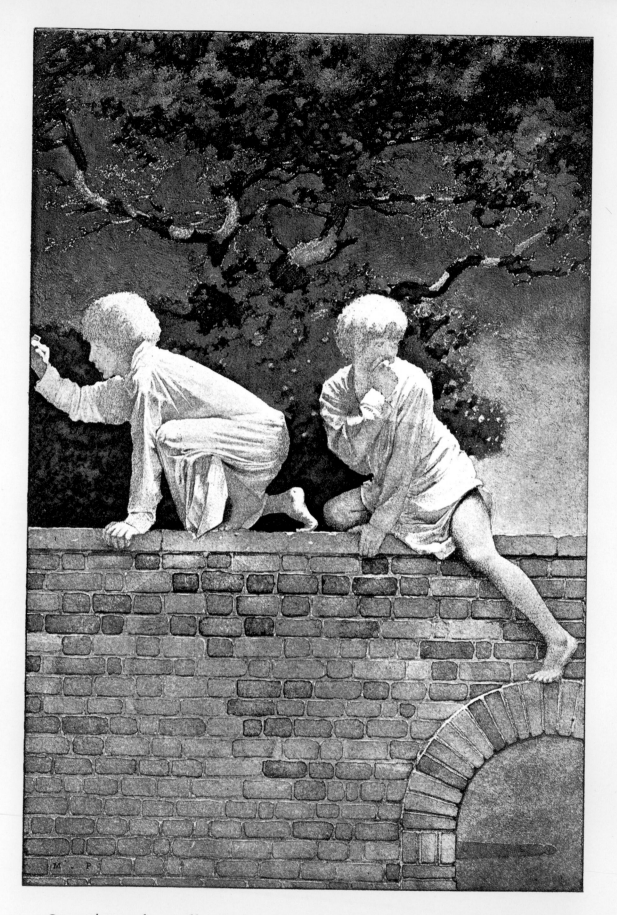

Onto the garden wall, which led in its turn to the roof of an outhouse.
ILLUSTRATION FOR THE BURGLARS

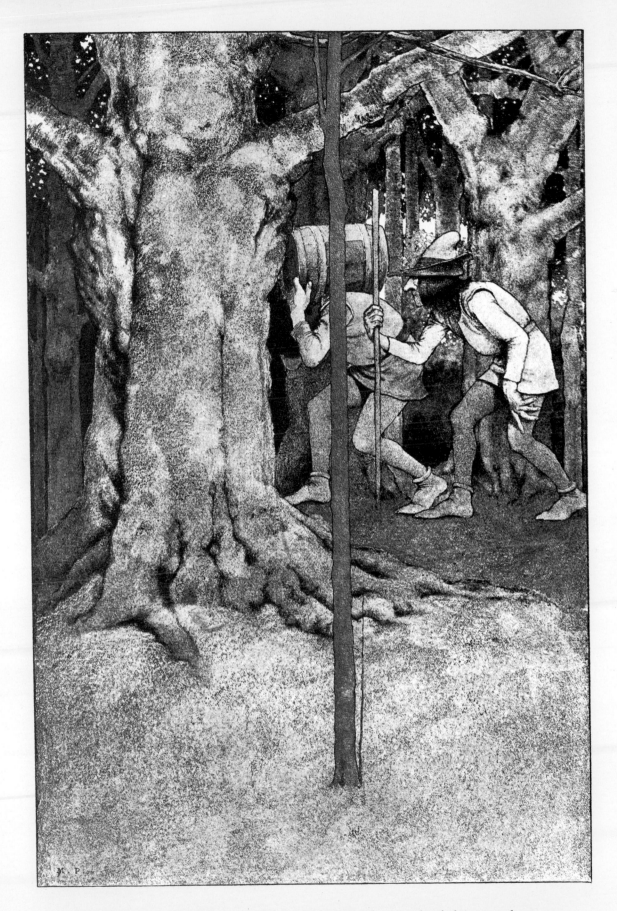

For them the orchard (a place elf-haunted, wonderful!) simply . . .
ILLUSTRATION FOR PROLOGUE: THE OLYMPIANS

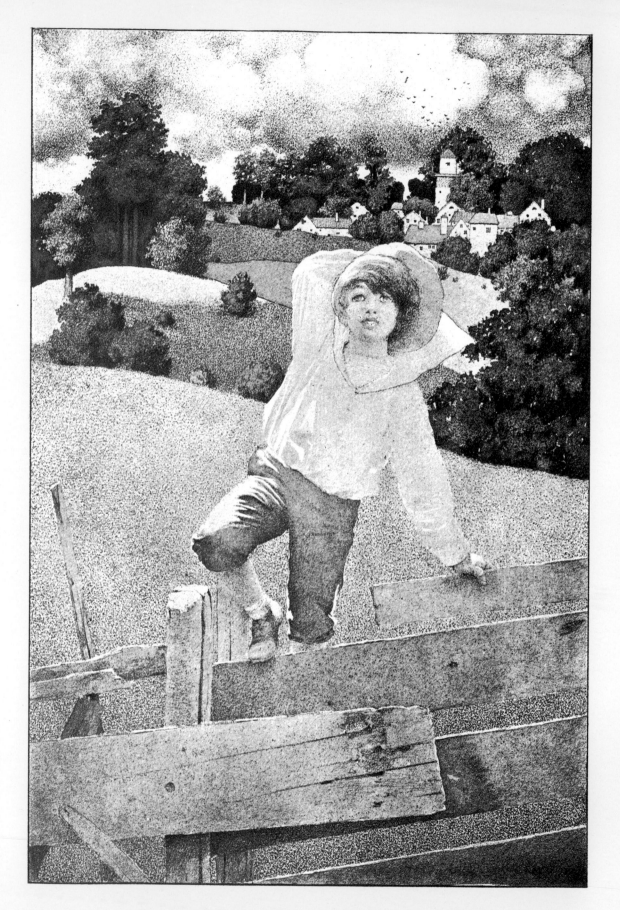

Out into the brimming sun-bathed world I sped.
ILLUSTRATION FOR A HOLIDAY

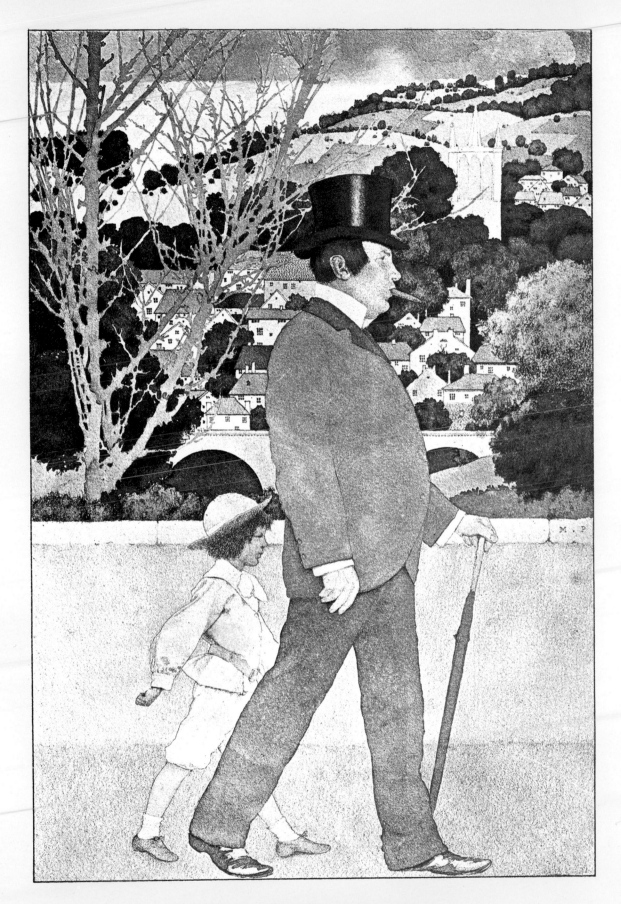

I took the old fellow to the station.
ILLUSTRATION FOR A WHITE-WASHED UNCLE

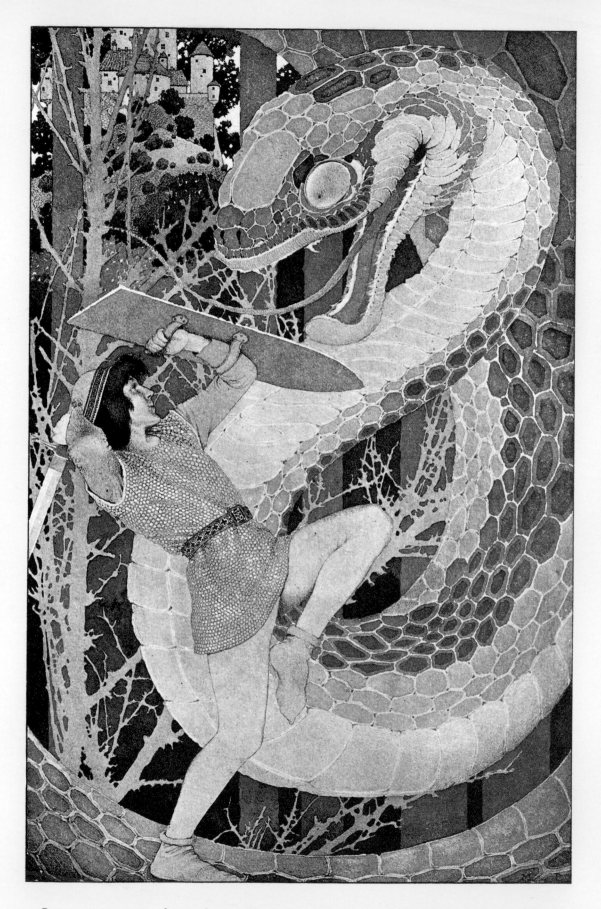

Once more were damsels rescued, dragons disembowelled, and giants ...
ILLUSTRATION FOR ALARUMS AND EXCURSIONS

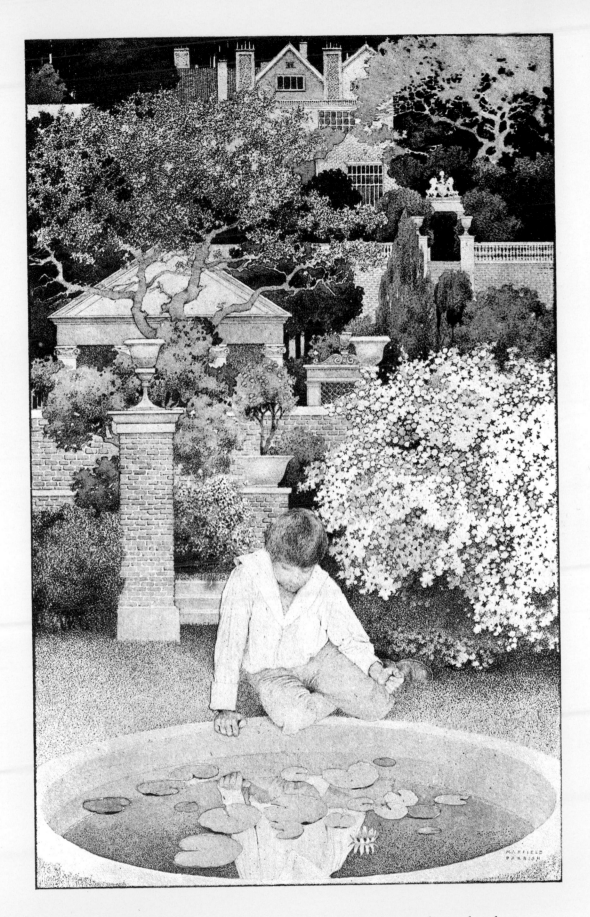

Lulled by the trickle of water, I slipped into dreamland.
ILLUSTRATION FOR THE FINDING OF THE PRINCESS

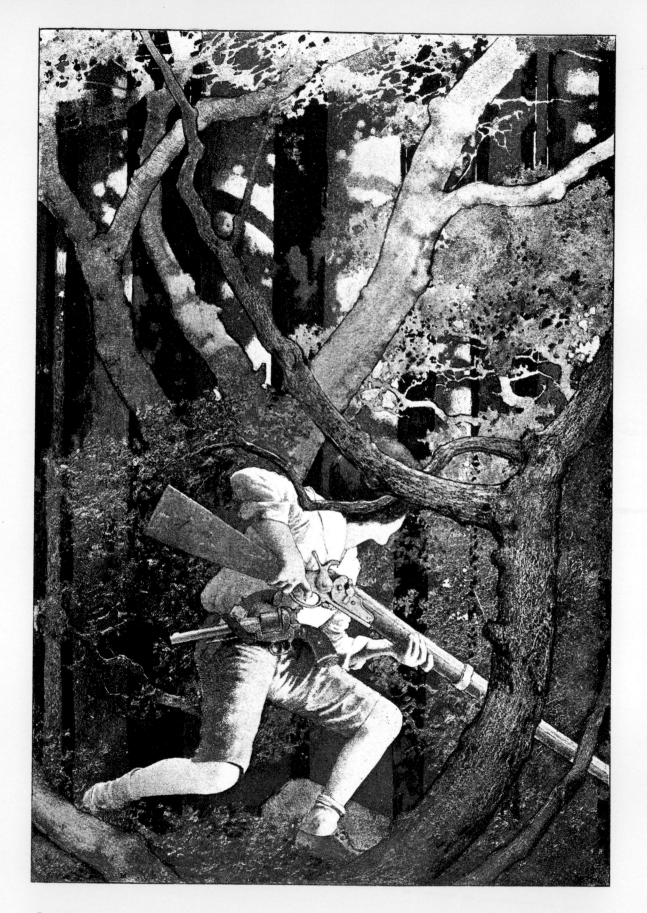

It was easy ... to transport yourself in a trice to the heart of a tropical forest.
ILLUSTRATION FOR SAWDUST AND SIN

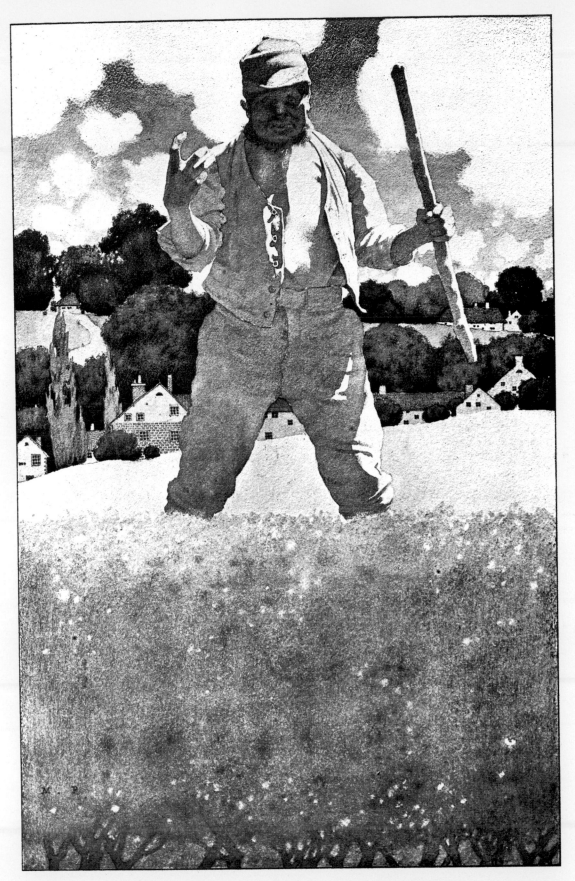

*Who would have thought . . . that only two short
days ago we had confronted each other on either side of a hedge.*

ILLUSTRATION FOR YOUNG ADAM CUPID

A great book open on his knee ... a score or so disposed within easy reach.
ILLUSTRATION FOR A HARVESTING

But yester-eve and the mummers were here!
ILLUSTRATION FOR SNOWBOUND

They make me walk behind, 'cos they say I'm too little, and musn't hear.
ILLUSTRATION FOR WHAT THEY TALKED ABOUT

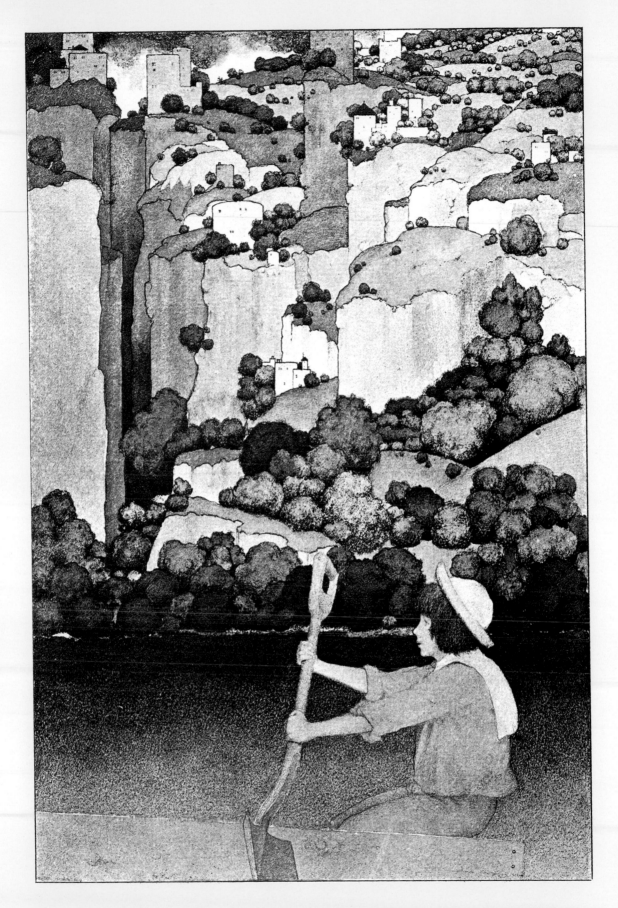

I'm Jason ... and this is the Argo ... and we're just going through the Hellespont.
ILLUSTRATION FOR THE ARGONAUTS

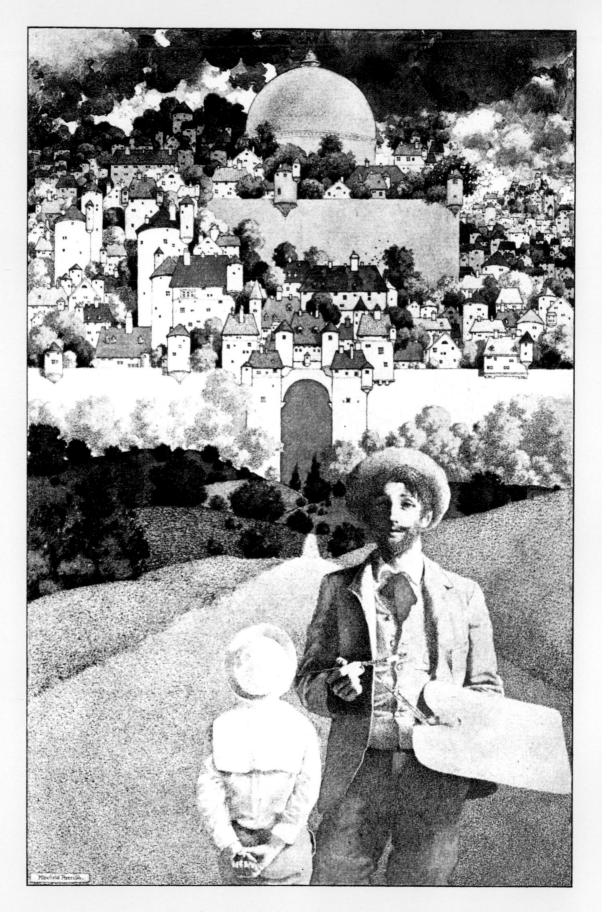

You haven't been to Rome, have you?
ILLUSTRATION FOR THE ROMAN ROAD

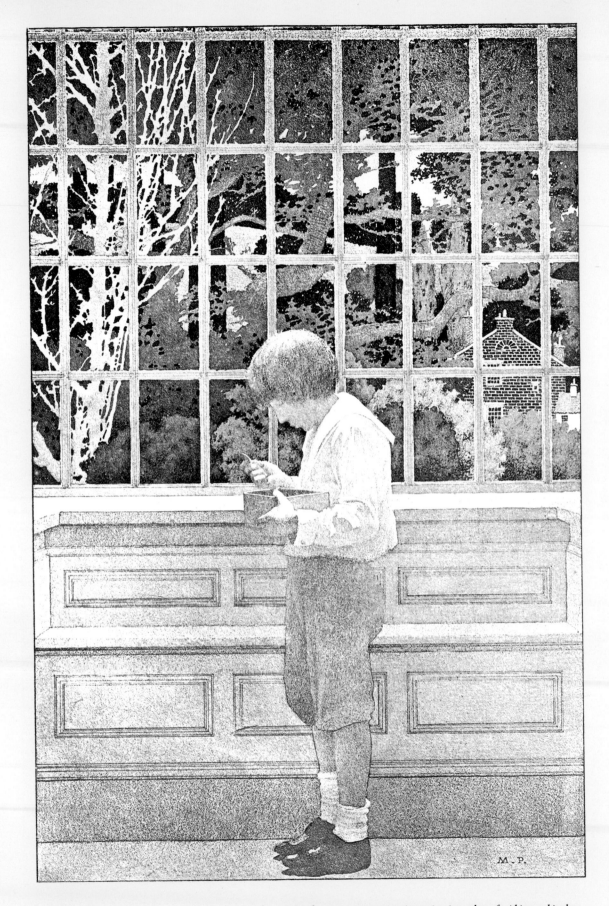

I drew it out and carried it to the window, to examine it in the failing light.
ILLUSTRATION FOR THE SECRET DRAWER

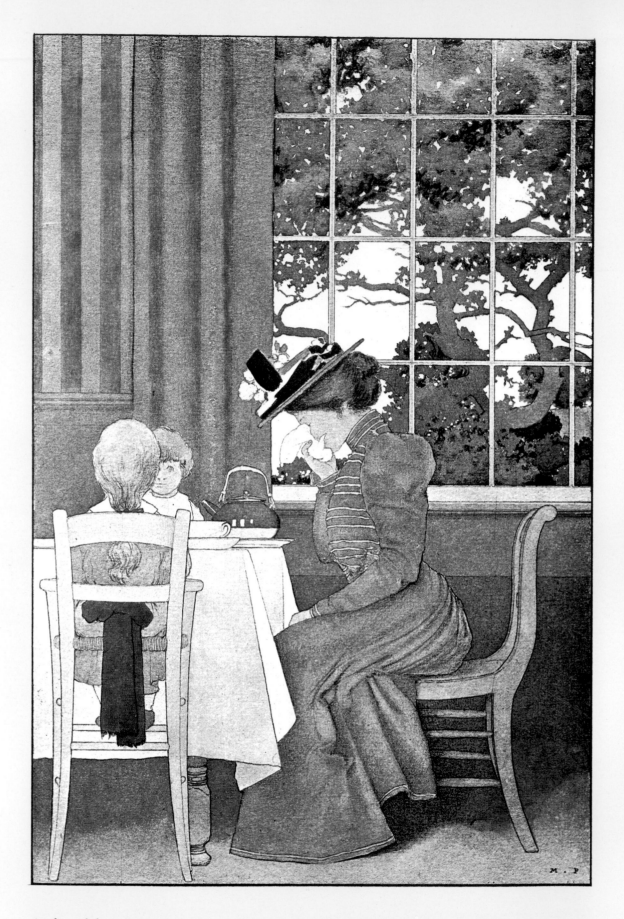

At breakfast Miss Smedley behaved in a most mean and uncalled-for manner.
ILLUSTRATION FOR EXIT TYRANNUS

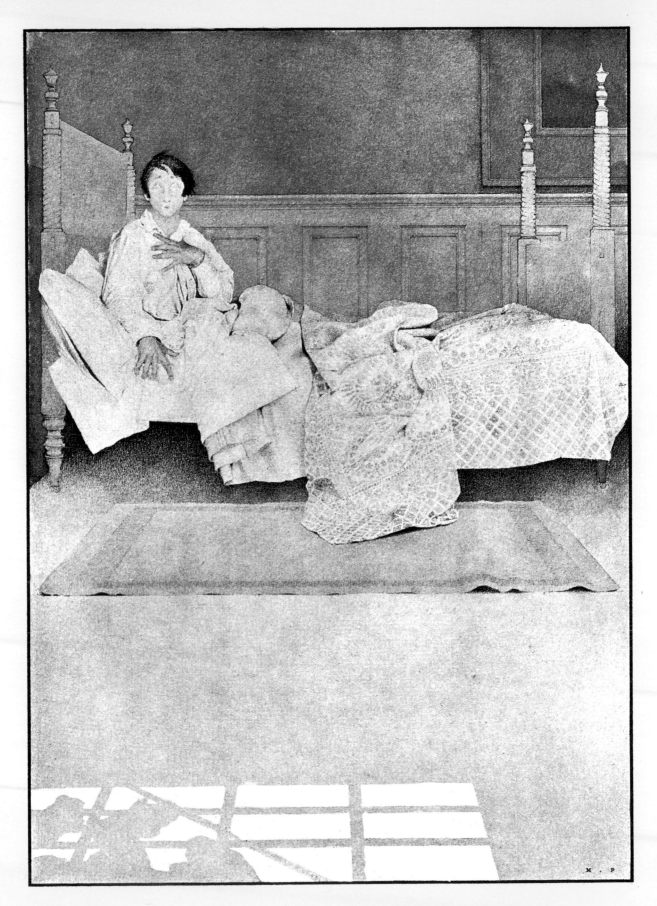

The procession passing solemnly across the moon-lit Blue Room ...
ILLUSTRATION FOR THE BLUE ROOM

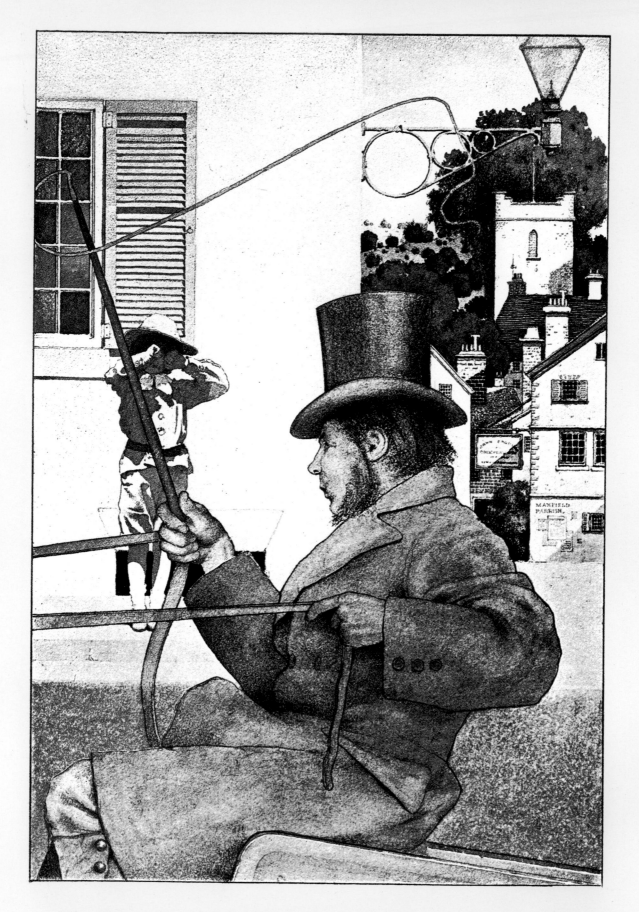

Why, Master Harold! whatever be the matter? Baint runnin' away, be ee?
ILLUSTRATION FOR A FALLING OUT

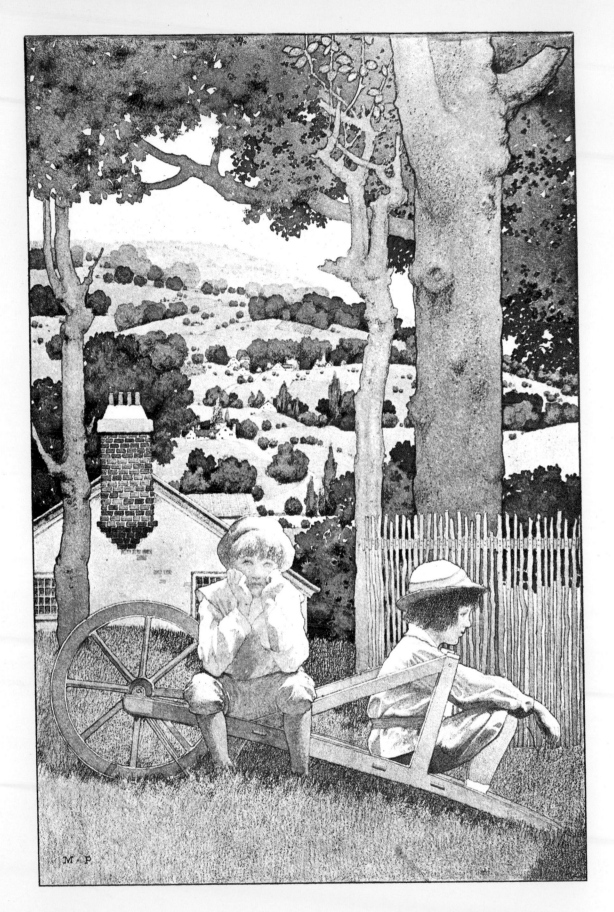

Finally we found ourselves sitting silent on an upturned wheelbarrow.
ILLUSTRATION FOR LUSISTI SATIS

ILLUSTRATIONS FOR

DREAM DAYS

BY KENNETH GRAHAME

PUBLISHED BY JOHN LANE: THE BODLEY HEAD

LONDON AND NEW YORK, 1902

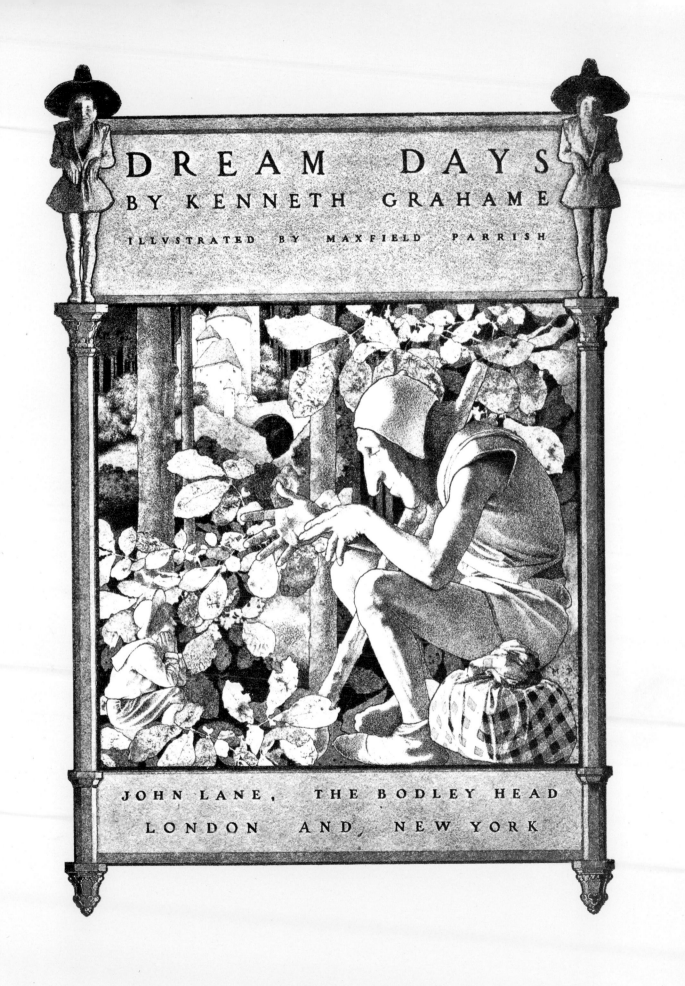

DREAM DAYS
BY KENNETH GRAHAME
ILLVSTRATED BY MAXFIELD PARRISH

JOHN LANE, THE BODLEY HEAD
LONDON AND NEW YORK

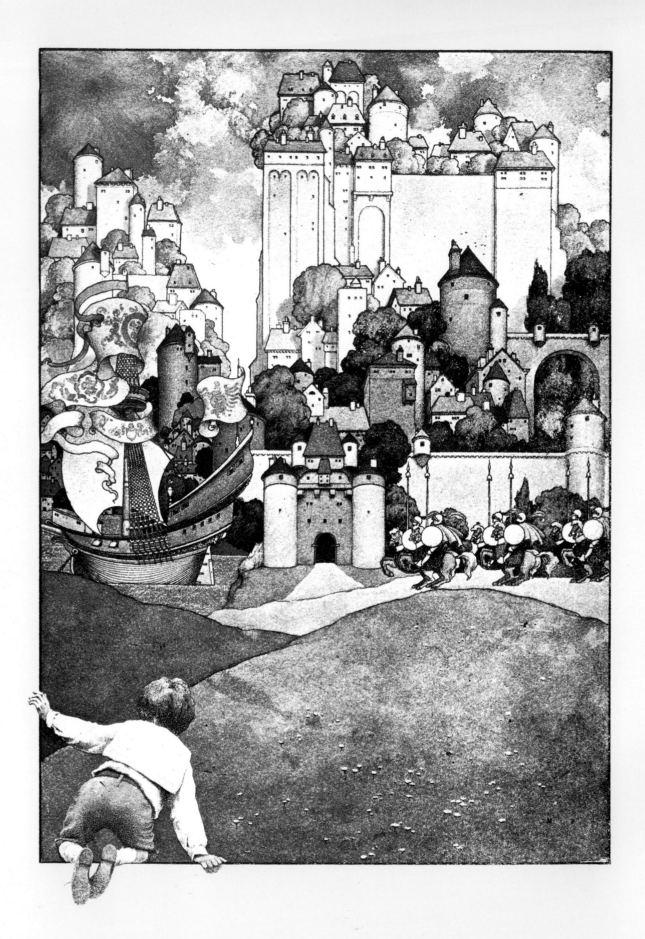

FRONTISPIECE; ILLUSTRATION FOR ITS WALLS WERE AS OF JASPER

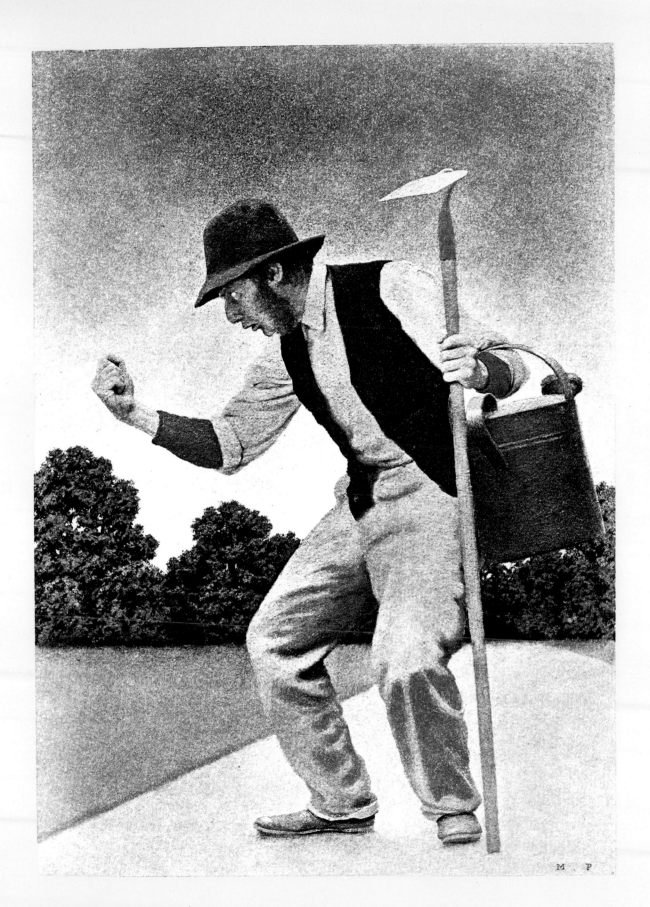

*Harold, . . . with a vision of a frenzied gardener,
pea-stickless, and threatening retribution.*

ILLUSTRATION FOR THE TWENTY-FIRST OF OCTOBER

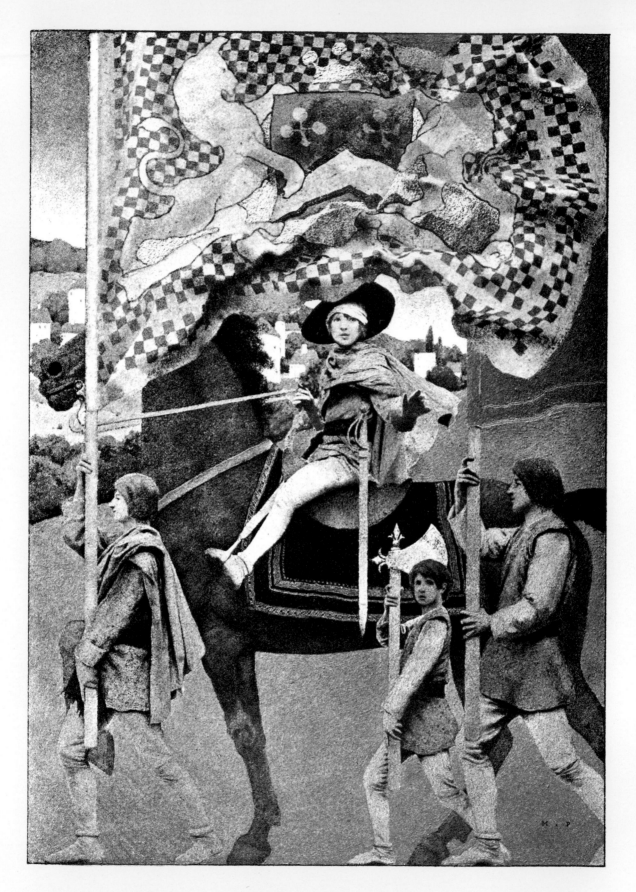

And, last of all, you—you, the General, the fabled hero—you would enter,
on your coal-black charger, your pale set face seamed by an interesting sabre-cut.
ILLUSTRATION FOR DIES IRÆ

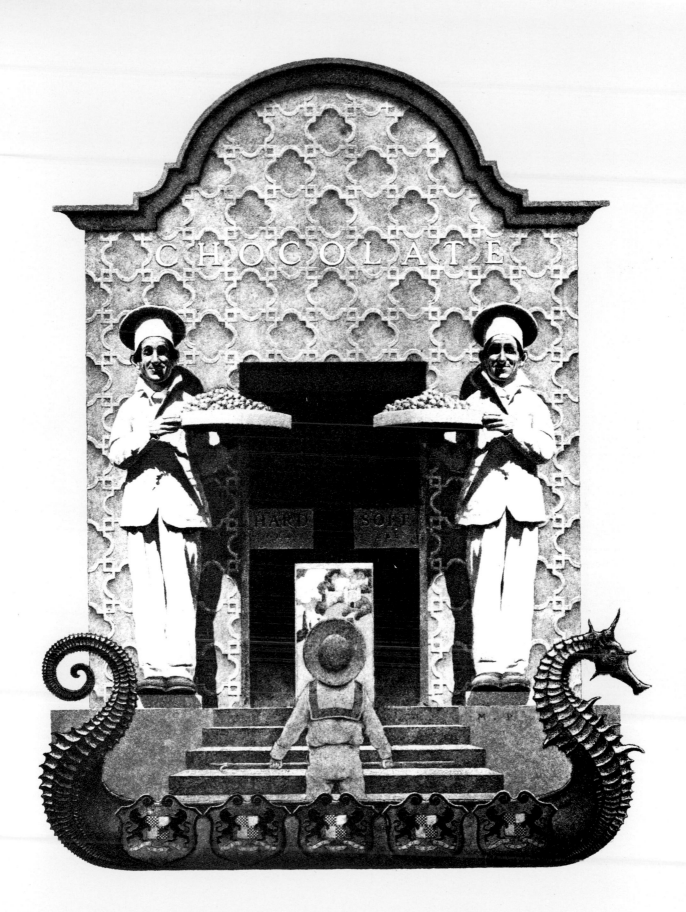

You go up the steps, and in at the door, and the very first place you come to is the Chocolate Room!
ILLUSTRATION FOR MUTABILE SEMPER

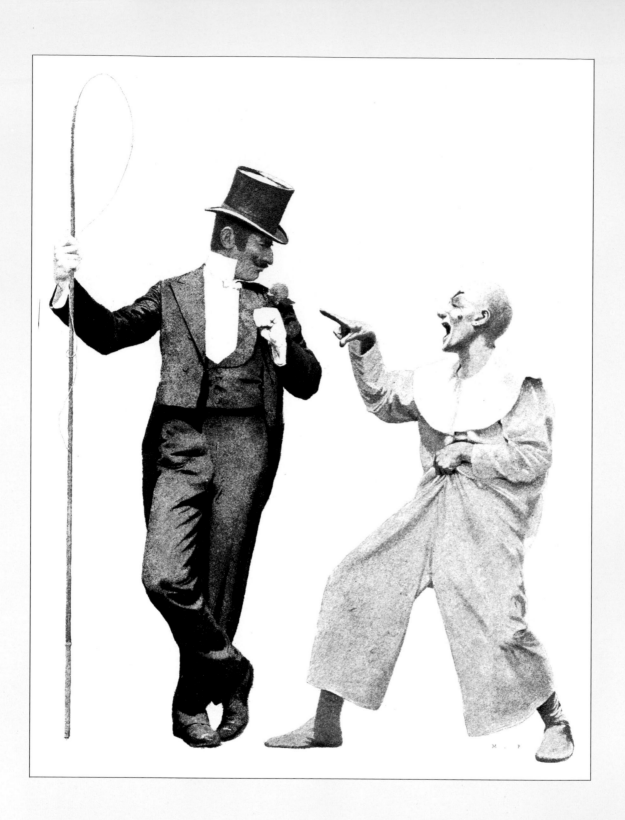

*Oh, to be a splendid fellow like this, self-contained, ready of speech,
agile beyond conception, braving the forces of society, his hand against
everyone, and yet always getting the best of it!*
ILLUSTRATION FOR THE MAGIC RING

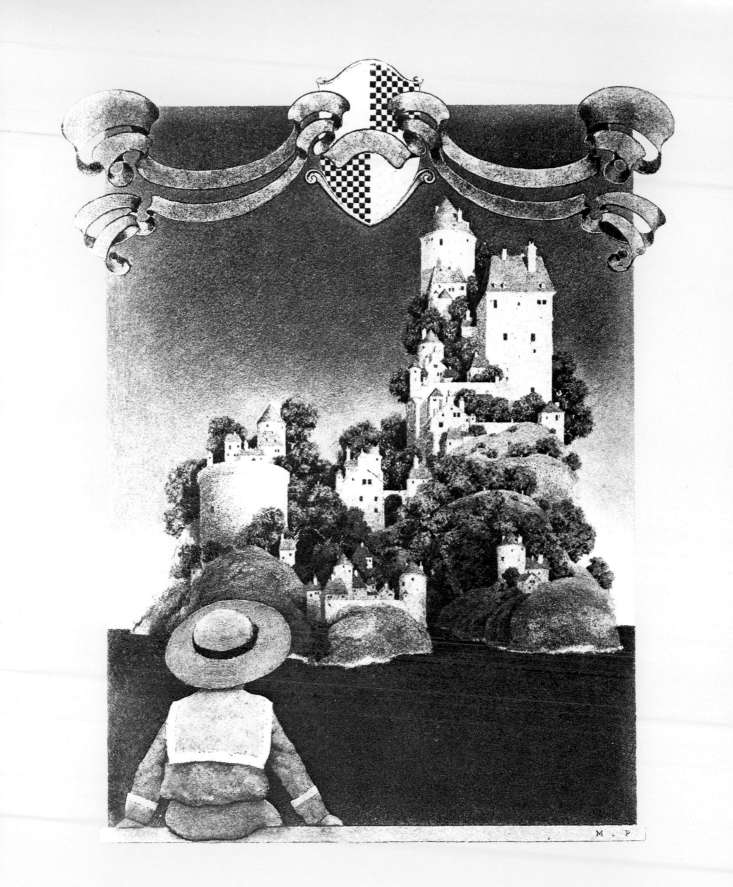

While every plunge of our bows brought us nearer to the happy island.
ILLUSTRATION FOR ITS WALLS WERE AS OF JASPER

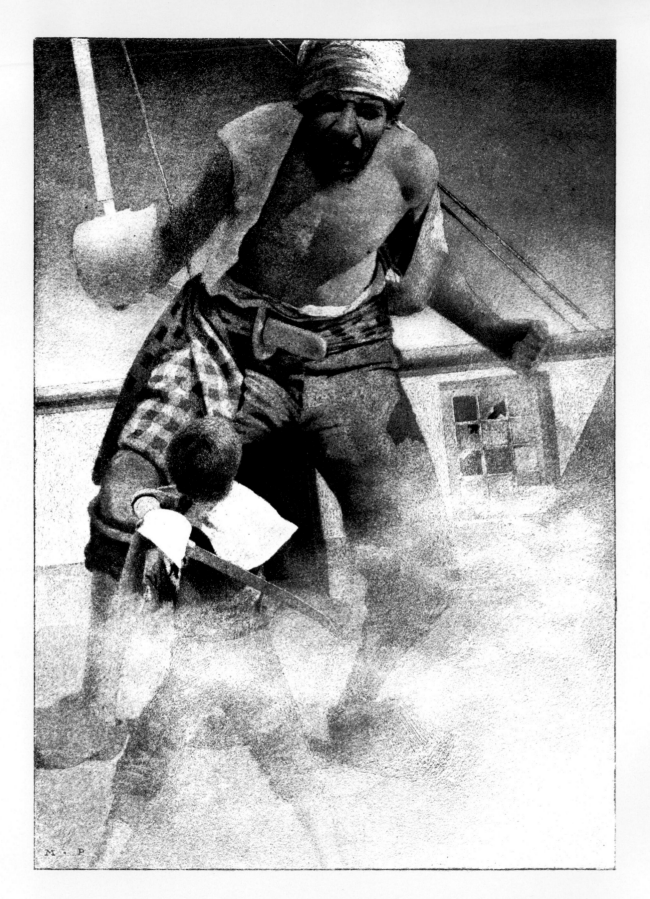

*All serious resistance came to an end
as soon as I had reached the quarter-deck and cut down the pirate chief.*
ILLUSTRATION FOR A SAGA OF THE SEAS

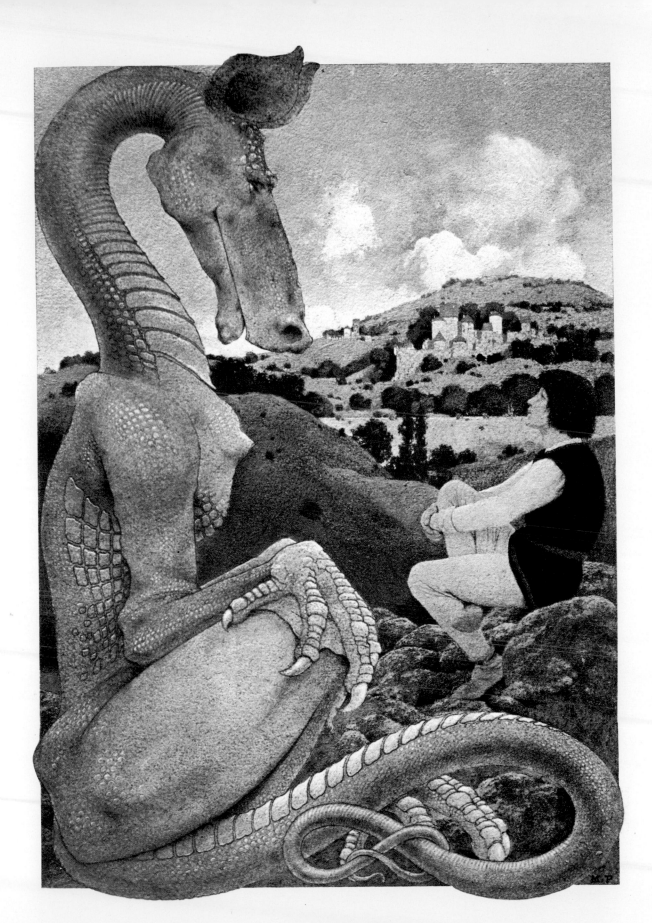

"What's your mind always occupied about?"
asked the Boy. "That's what I want to know."
ILLUSTRATION FOR THE RELUCTANT DRAGON

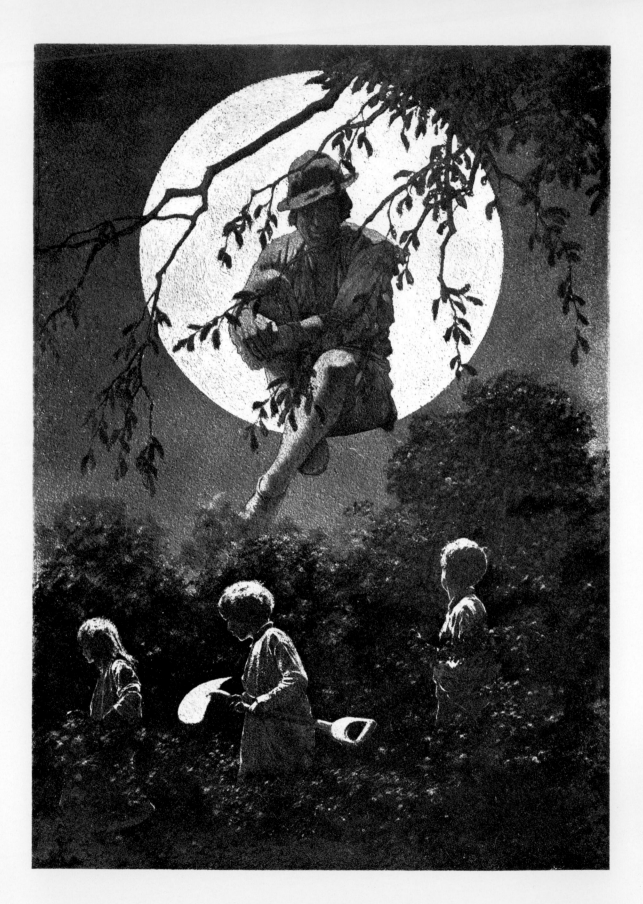

As we turned to go, the man in the moon,
tangled in elm boughs, caught my eye for a moment.
ILLUSTRATION FOR A DEPARTURE

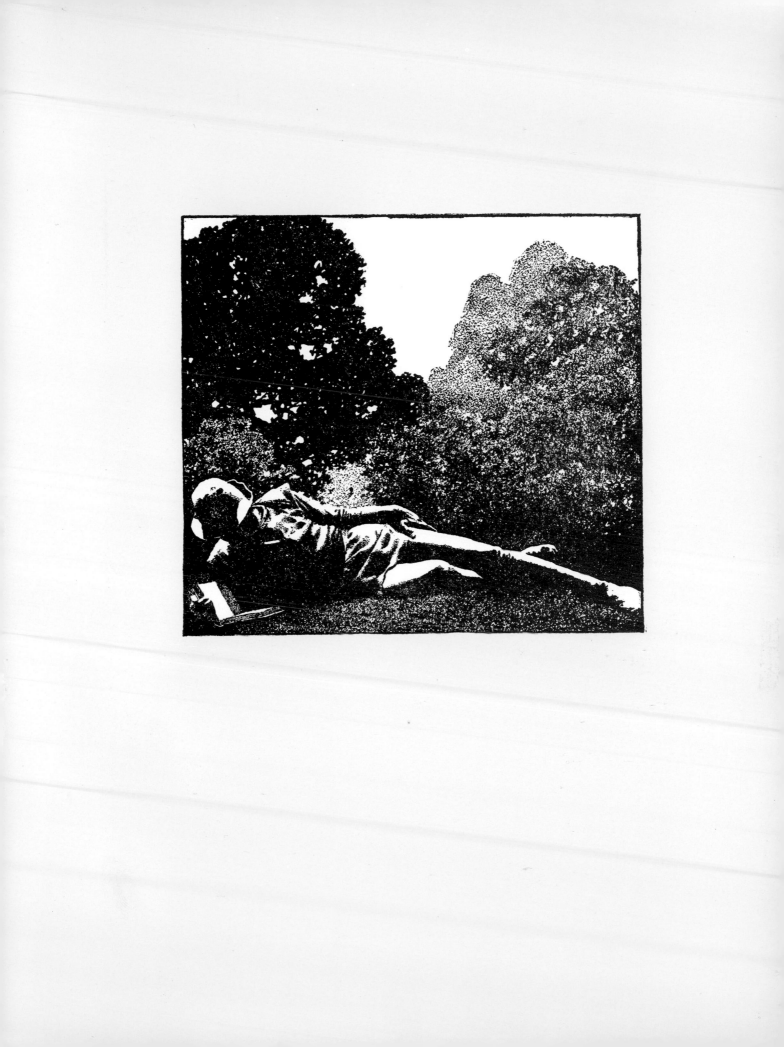

ILLUSTRATIONS FOR

"THE GREAT SOUTHWEST"

BY RAY STANNARD BAKER

CENTURY MAGAZINE, MAY THROUGH AUGUST 1902

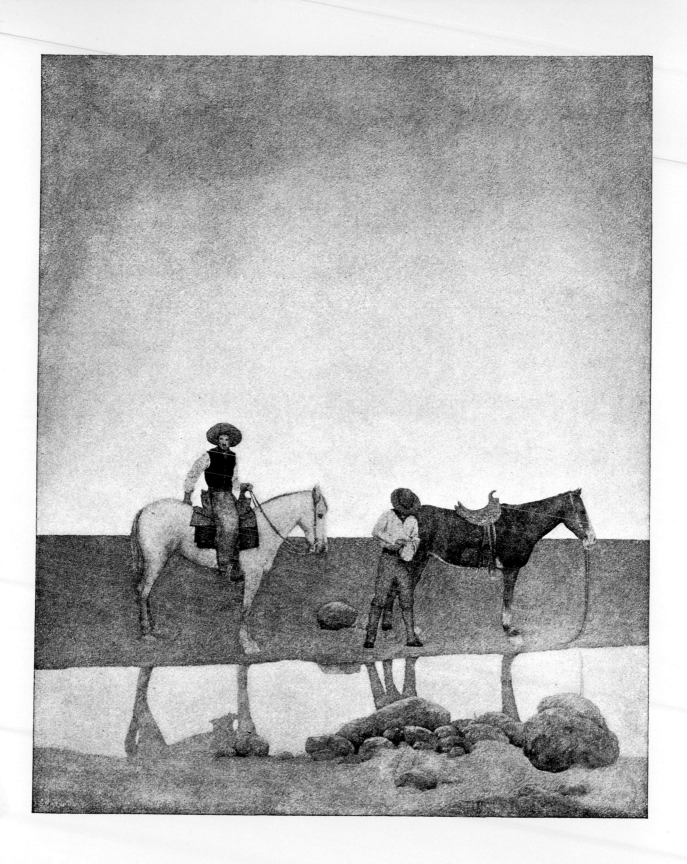

Cow-Boys. (MAY 1902)

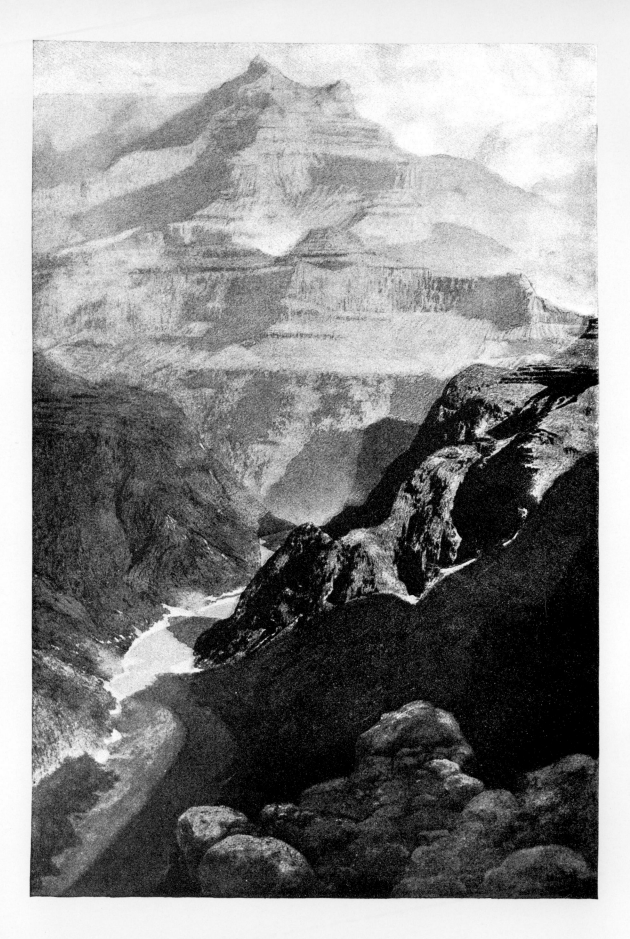

The Grand Cañon of the Colorado. (MAY 1902)

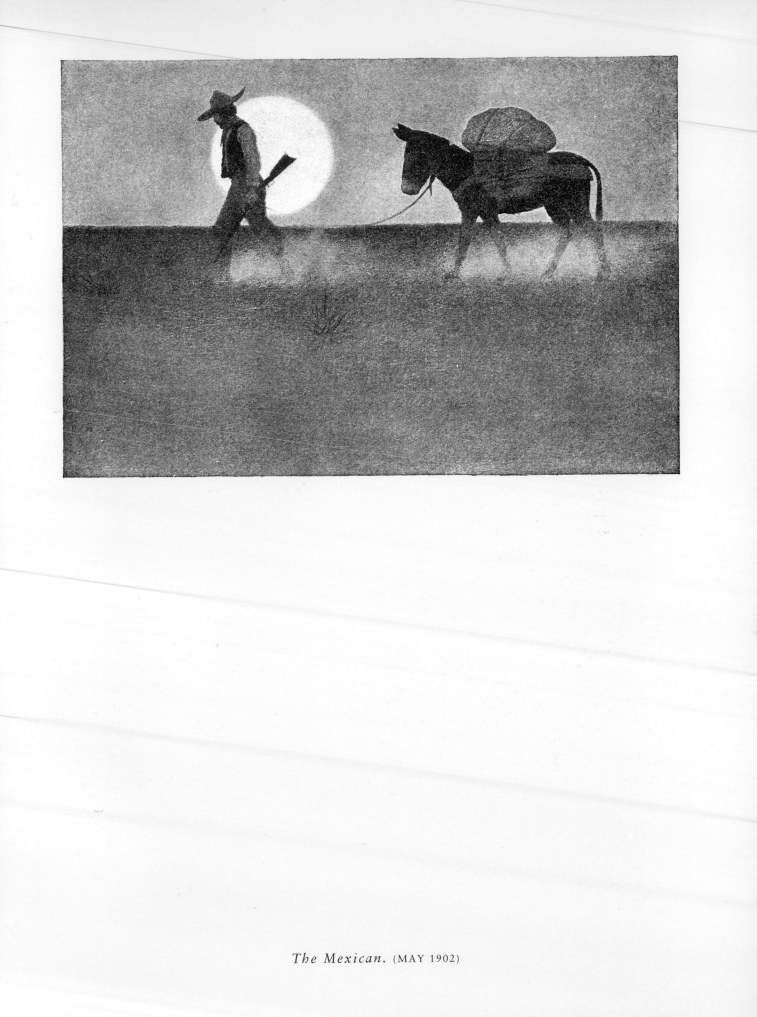

The Mexican. (MAY 1902)

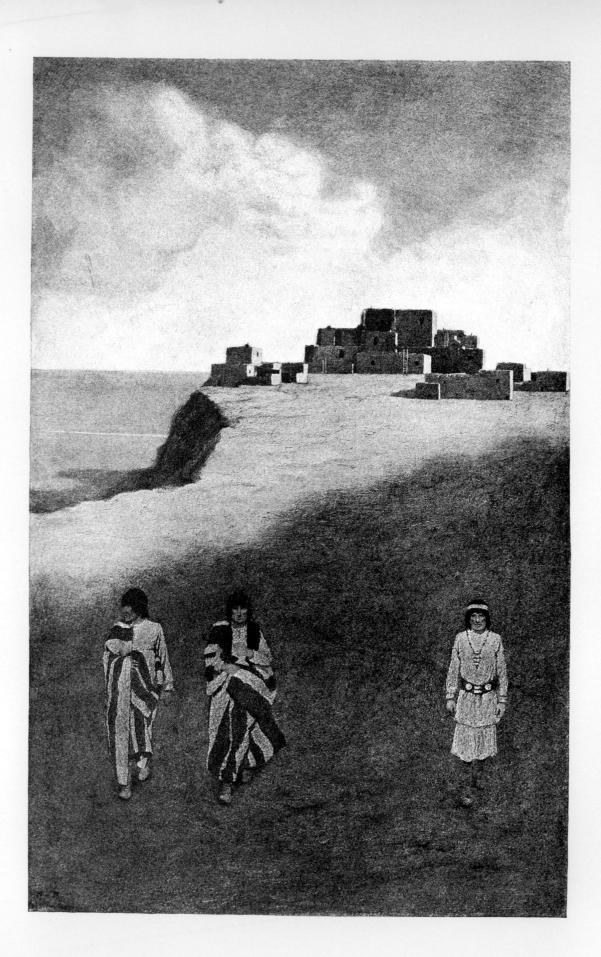

Pueblo Dwellings. (MAY 1902)

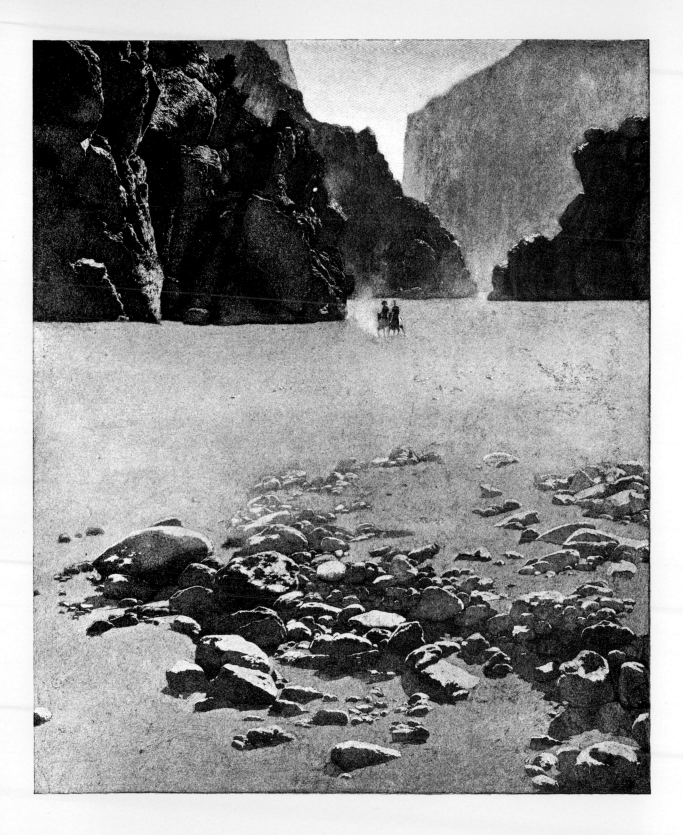

The bed of a typical Southwest river—a raging torrent perhaps for a month, but dry as dust for the other eleven months. (JUNE 1902)

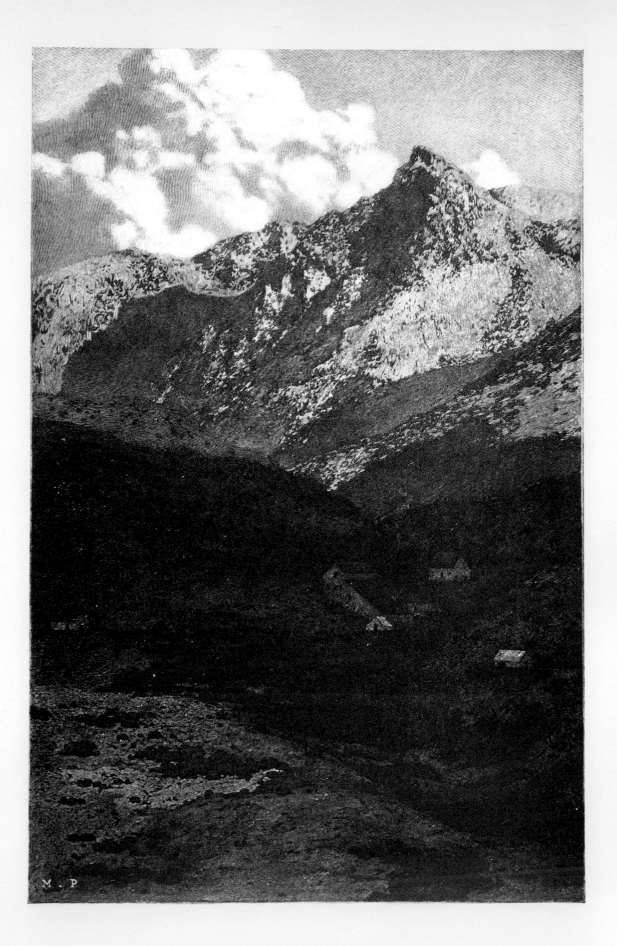

A Gold-Mine in the Desert. (JUNE 1902)

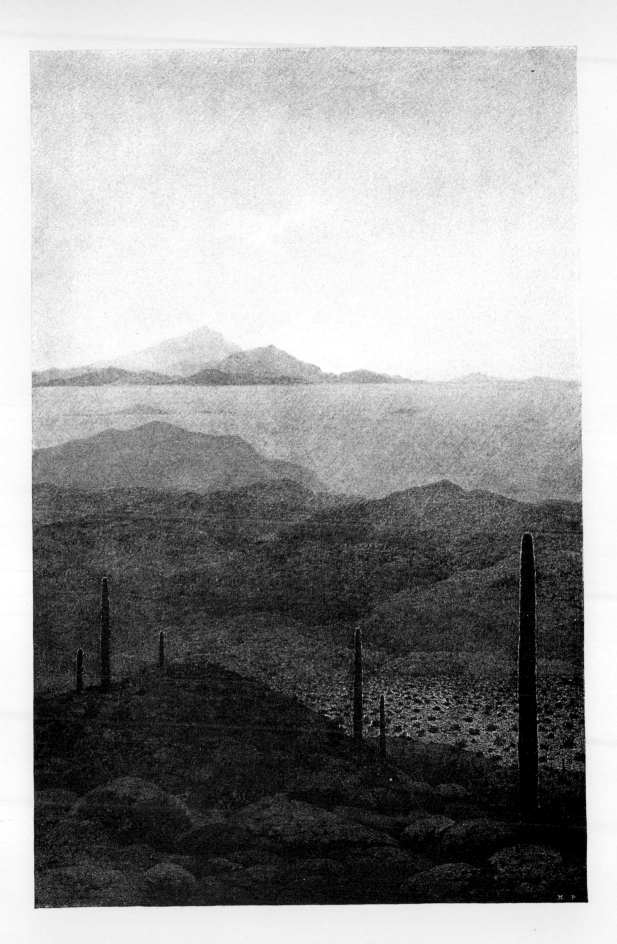

Sunrise in the Desert. (JUNE 1902)

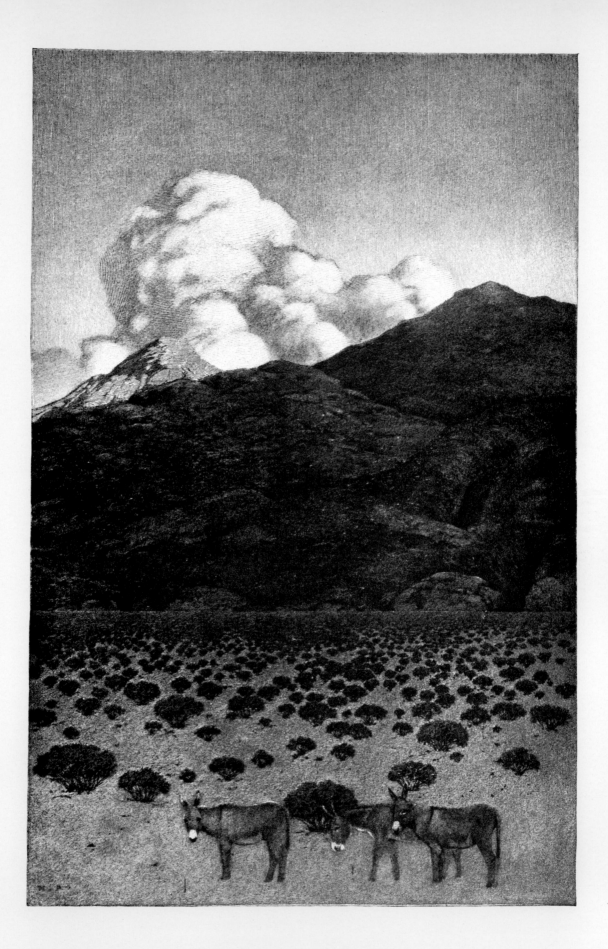

Formal Growth in the Desert. (JUNE 1902)

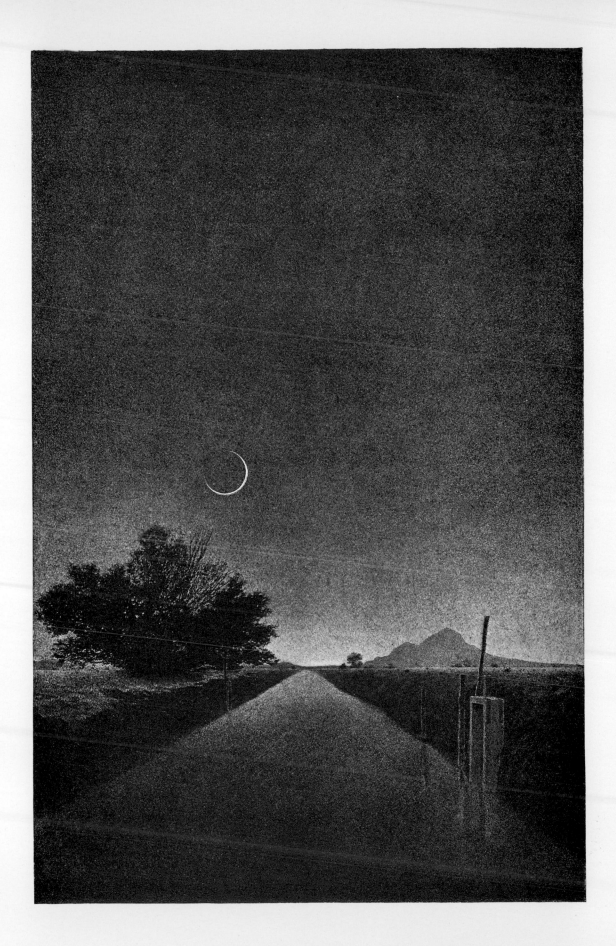

Irrigating-Canal in the Salt River Valley. (JULY 1902)

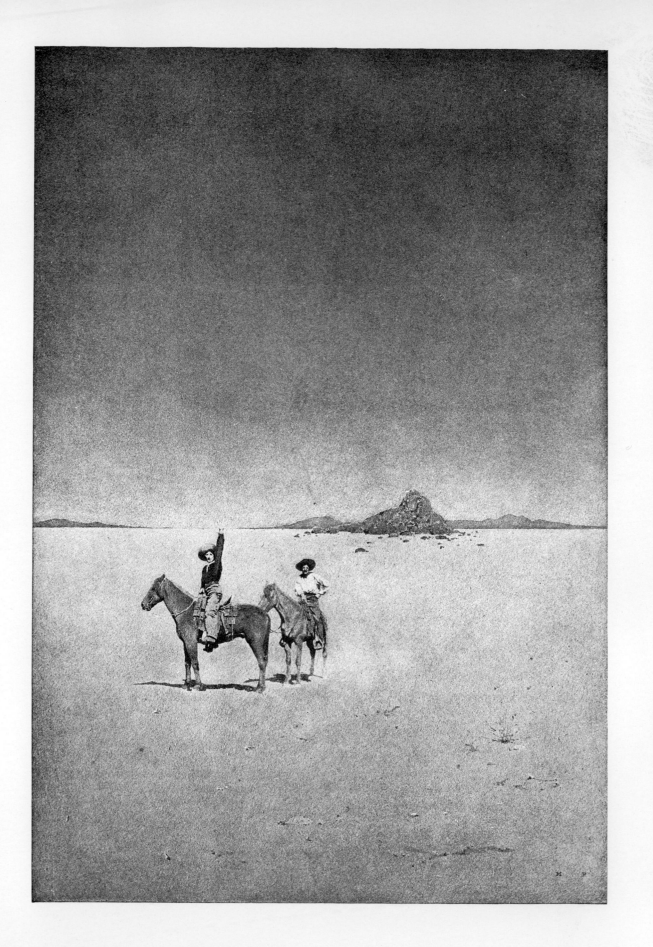

The Desert without Water. (JULY 1902)

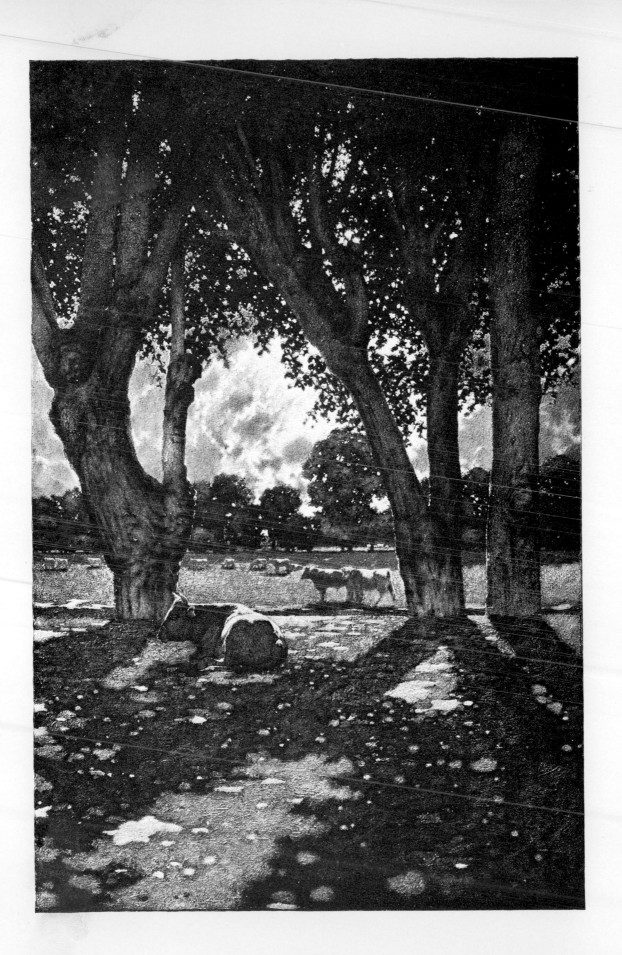

The Desert with Water. (JULY 1902)

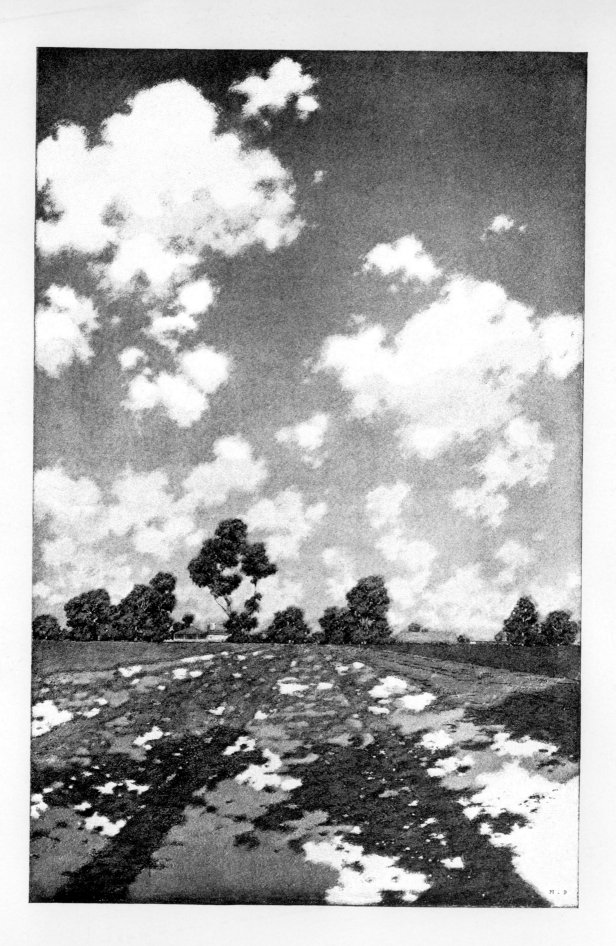

Water Let in on a Field of Alfalfa. (JULY 1902)

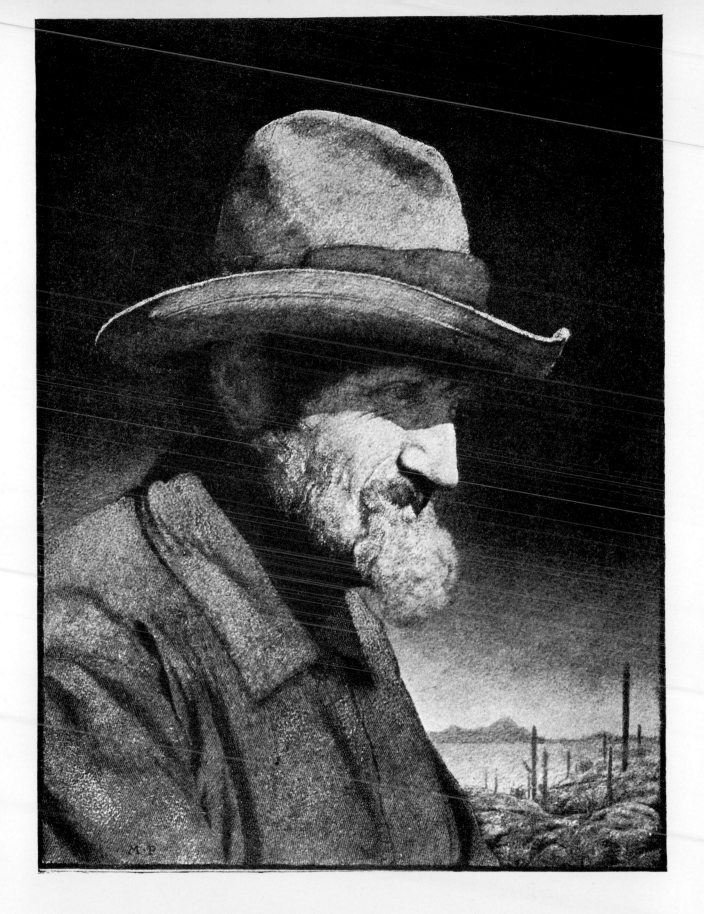

A Southwestern Type: Bill Sachs, "The Flying Dutchman,"
An Often-Held-up Stage-Driver of the Old Days. (AUGUST 1902)

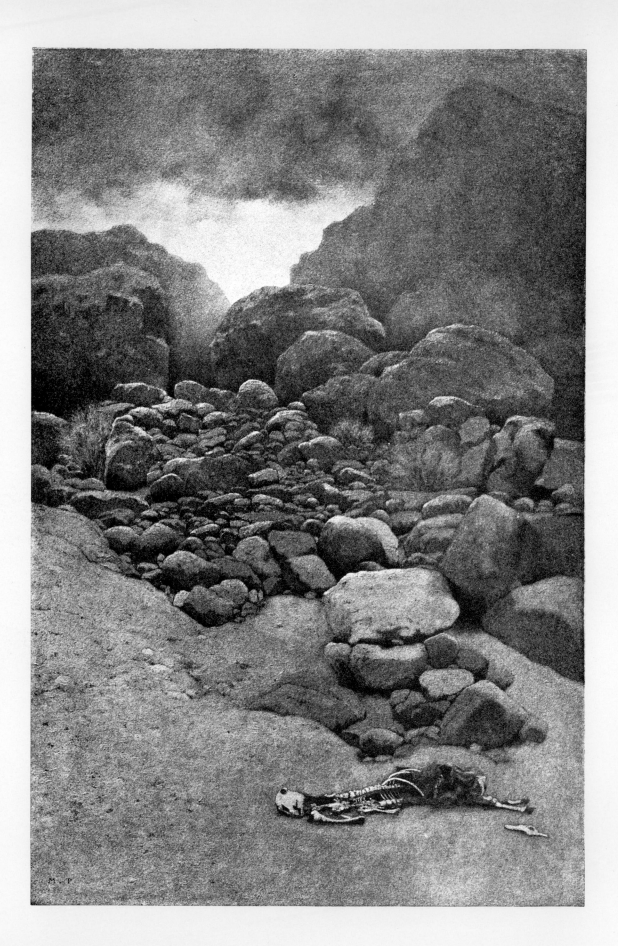

The Sign of a Thirsty Land. (AUGUST 1902)

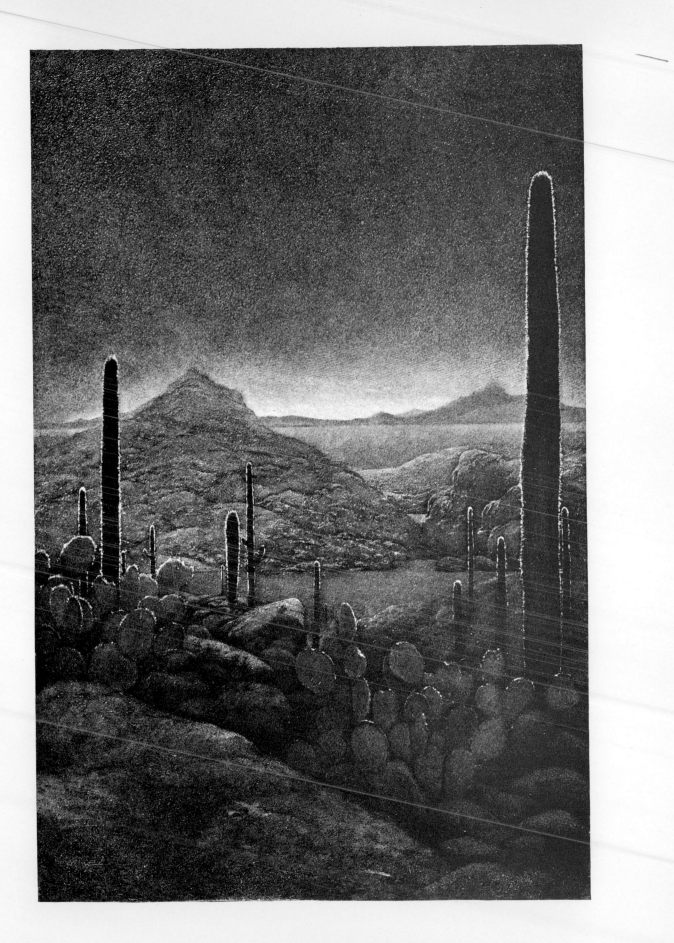

The Cactus Came, Especially the Prickly-Pear. (AUGUST 1902)

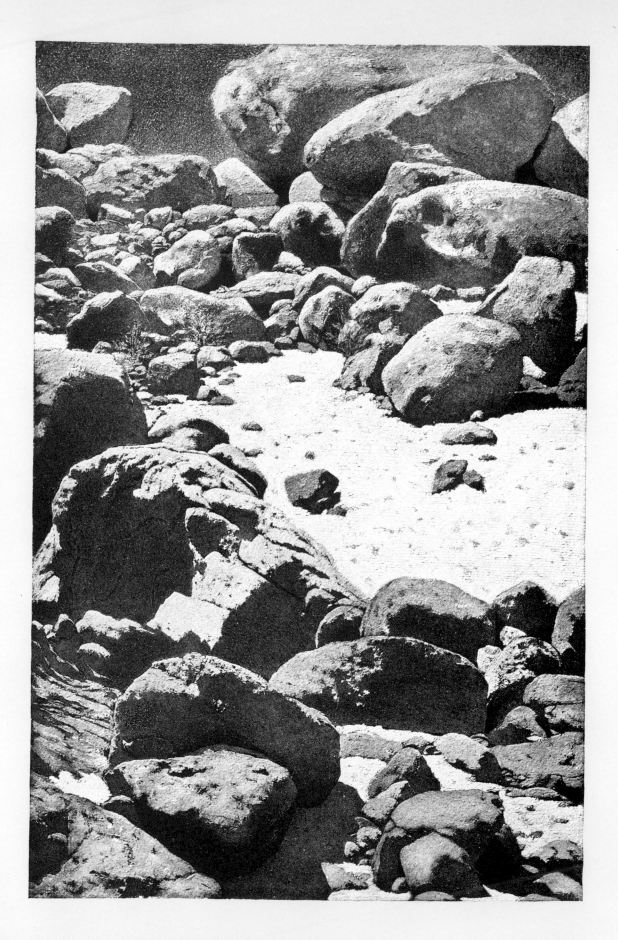

In the Track of the Flood. (AUGUST 1902)